Imprint

Editor: Katharina Feuer

Editorial assistance: Anastassia Ksenofontova

Photos (location): Andrey Golovanov (Bosco), Sergey (Gorki), Roman Pechorin (Garage)

All other photos by Katharina Feuer

Introduction: Katharina Feuer

Layout & Pre-press: Katharina Feuer, Jan Hausberg

Imaging: Jan Hausberg

Translations: Artes Translations, Dr. Suzanne Kirkbright
Dr. Suzanne Kirkbright (English/introduction), Brigitte Villaumié (French), Carmen de Miguel (Spanish), Maria-Letizia Haas (Italian), Nina Hausberg (German, English/recipes)

Produced by fusion publishing GmbH, Stuttgart . Los Angeles www.fusion-publishing.com

Special thanks to Nikolay Grachev, Anastassia Ksenofontova, Waike Papke (swissôtel Krasnye Holmy Moscow), Robert Soukup for their great support

Published by teNeues Publishing Group

teNeues Verlag GmbH + Co.KG
International Sales Division
Speditionsstr. 17
40221 Düsseldorf, Germany
Tel.: 0049-(0)211-994597-0
Fax: 0049-(0)211-994597-40
E-mail: books@teneues.de

teNeues Publishing Company
16 West 22nd Street
New York, NY 10010, USA
Tel.: 001-212-627-9090
Fax: 001-212-627-9511

teNeues Publishing UK Ltd.
P.O. Box 402
West Byfleet, KT14 7ZF
Great Britain
Tel.: 0044-1932-403509
Fax: 0044-1932-403514

teNeues France S.A.R.L.
4, rue de Valence
75005 Paris, France
Tel.: 0033-1-55766205
Fax: 0033-1-55766419

teNeues Ibérica S.L.
c/Velázquez, 57 6.° izda.
28001 Madrid, Spain
Tel.: 0034-657-132133

teNeues
Representative Office Italy
Via San Vittore 36/1
20123 Milano, Italy
Tel.: 0039-(0)347-7640551

Press department: arehn@teneues.de
Phone: 0049-2152-916-202

www.teneues.com

ISBN-10: 3-8327-9147-7
ISBN-13: 978-3-8327-9147-6

© 2006 teNeues Verlag GmbH + Co. KG, Kempen

Printed in Italy

Picture and text rights reserved for all countries.
No part of this publication may be reproduced in any manner whatsoever.

All rights reserved.

While we strive for utmost precision in every detail, we cannot be held responsible for any inaccuracies, neither for any subsequent loss or damage arising.

Bibliographic information published by Die Deutsche Bibliothek.
Die Deutsche Bibliothek lists this publication in the Deutsche Nationalbibliografie;
detailed bibliographic data is available in the Internet at http://dnb.ddb.de.

Average price reflects the average cost for a dinner main course without beverages. Recipes serve four.

Contents	Page
Introduction	**5**
Biscuit	**10**
Bocconcino	**16**
Bosco Bar	**18**
Cantinetta Antinori	**22**
City Space Bar & Lounge	**28**
Dolf	**32**
Galereya	**38**
Garage	**44**
Genatsvale VIP	**48**
Gorki	**50**
Indus	**52**
Le Duc	**58**
Maki Café	**60**
Metropol	**62**
Mon Café	**64**
Moskovsky	**68**
Nostalgie	**70**
Oblomov	**74**
Pavillion	**78**
Peperoni	**84**
Propaganda	**88**
Shatush	**92**
Shinok	**98**
Suzy Wong	**100**
Uley	**106**
Vanil	**110**
Vertinsky	**118**
Villa	**124**
Vogue Café	**128**
Map	**134**

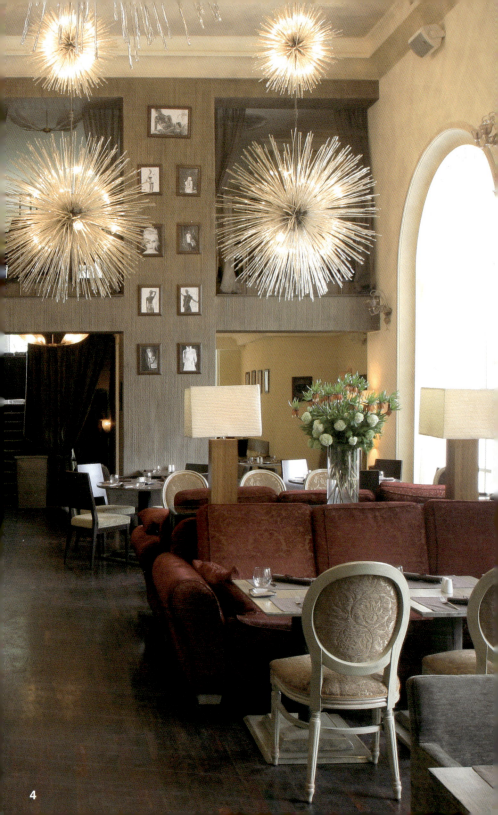

Introduction

Moscow is constantly in a state of transition; vibrant and loud colors are in order, after decades of monotonous gray. Western consumer items, business ideas and international influences are flowing into this now open country.
The gastronomy scene is also multi-cultural and alive; and with everything that a city of millions has to offer. Try out Asian, like at *Vertinsky* or *Suzy Wong*, Italian, at *Cantinetta Antinori* or *Bocconcino*, or *Indian*, like at *Indus*.
But sometimes the owners, names and design change so quickly that even connoisseurs of the many restaurants, bars and clubs find it difficult to keep up. Anyone who enjoys success has become a trendsetter, like *Galereya* or *Propaganda*, or a classic, like *Gorki* or *Metropol*.
Many Russian architects and designers collect styles and impressions from around the world. Influenced by Russian culture, they filter out what suits Moscow and rely on their intuition and understanding to use ideas.
No limits are set to the imagination and sometimes the wallet when it comes to design and furnishing. At the French restaurant *Le Duc*, admire the interior imitation of Gothic church style, or the *Shinok*, whose small farm and live animals occasionally distract the guests from Ukrainian specialties. In the café named after it, *Vogue* magazine presents glossy prints of androgynous models. Some restaurants are winners simply because of their unique location, like the *Moskovsky* at the *Hotel National* with a view of the Kremlin, as well as *Bosco Bar* on the ground level of the famous department store *GUM*, or *City Space* towering 460 feet over Moscow with a 360°-view of the city.
The choice is endless, but in this book is restricted to an exclusive 29 restaurants that show how Moscow is a popular metropolis with a lively gourmet scene.

Katharina Feuer

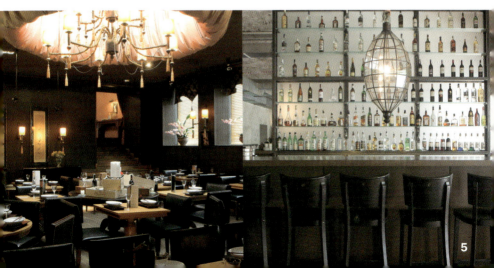

Einleitung

Moskau befindet sich im steten Wandel; nach jahrzehntelangem Einheitsgrau ist bunt und schrill angesagt. Westliche Konsumgüter, Geschäftsideen und Einflüsse aus der ganzen Welt halten Einzug in das nun offene Land.
Multikulturell und lebhaft ist auch die Gastronomieszene; es gibt nichts, was es in der Millionenstadt nicht gibt. Ob Asiatisch, wie im *Vertinsky* oder *Suzy Wong*, Italienisch, wie in der *Cantinetta Antinori* oder im *Bocconcino* oder Indisch, wie im *Indus*.
Besitzer, Namen und Design wechseln jedoch manchmal so schnell, dass es selbst Kennern der unzähligen Restaurants, Bars und Clubs schwer fällt, den Überblick zu behalten. Geschafft hat es, wer zum Trendsetter wird, wie *Galereya* oder *Propaganda*, oder zum Klassiker, wie *Gorki* oder *Metropol*.
Viele russische Architekten und Designer sammeln Stile und Eindrücke aus aller Welt. Geprägt durch die russische Kultur und Ästhetik filtern sie heraus, was zu Moskau passt und verwenden Ideen nach eigenem Empfinden und Verständnis.
So sind bei Design und Ausstattung der Fantasie und manchmal der Geldbörse keine Grenzen gesetzt. Zu bestaunen beim französischen Restaurant *Le Duc*, dessen Innenraum einer gotischen Kirche nachempfunden ist oder dem *Shinok*, dessen kleiner Bauernhof mit lebenden Tieren die Gäste beizeiten von den ukrainische Spezialitäten ablenkt. Die Zeitschrift *Vogue* präsentiert im gleichnamigen Café Hochglanzbilder androgyner Models.
Manches Restaurant gewinnt allein schon durch seine spezielle Lage, wie das *Moskovsky* im *Hotel National* mit Blick auf den Kreml, ähnlich die Bosco Bar im Erdgeschoss des berühmten Kaufhaus *GUM* oder das *City Space* in 140 Metern Höhe über Moskau mit einem 360°-Ausblick auf die Stadt.
Die Auswahl ist unendlich, doch in diesem Buch begrenzt auf 29 exklusive Restaurants, die zeigen, dass Moskau eine angesagte Metropole mit einer lebendigen Gourmetszene ist.

<div style="text-align: right;">Katharina Feuer</div>

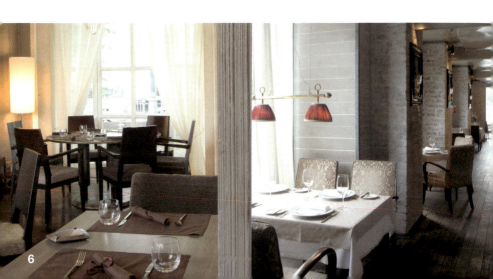

Introduction

Moscou est en constante mutation; après des décennies de grisaille généralisée, l'heure est aux couleurs bariolées et tapageuses. Des biens de consommation occidentaux, des idées commerciales et des influences du monde entier font leur apparition dans ce pays désormais ouvert.
La scène de la gastronomie également, est animée et multiculturelle on trouve absolument tout dans cette métropole. Saveurs asiatiques, comme au *Vertinsky* ou au *Suzy Wong*, italiennes comme à la *Cantinetta Antinori* ou au *Bocconcino*, indiennes comme à *l'Indus*.
Mais les propriétaires, les noms et le design changent parfois si vite que même les connaisseurs de ces innombrables restaurants, bars et clubs ont du mal à s'y retrouver. La réussite sourit à ceux qui savent imposer des tendances, comme *Galereya* ou *Propaganda*, ou rester classiques tels que *Gorki* ou *Metropol*.
De nombreux architectes et créateurs russes glanent des idées de style et des impressions dans le monde entier. Imprégnés de la culture et de l'esthétique russes, ils sélectionnent celles qui conviennent à Moscou et les exploitent selon leur perception et leur approche personnelle.
C'est ainsi qu'en matière de design et d'aménagement, l'imagination, et parfois le budget, ne connaissent aucune limite. Ce qu'on peut admirer dans le restaurant français *Le Duc*, dont l'intérieur ressemble à une église gothique ou au *Shinok*, dont la petite ferme avec ses animaux vivants distrait les hôtes, en temps voulu, des spécialités ukrainiennes. La revue *Vogue* présente, dans le café du même nom, des photos sur papier glacé de mannequins androgynes.
Certains restaurants doivent leur succès à leur emplacement particulier, tels le *Moskovsky* situé dans *l'Hôtel National* avec vue sur le Kremlin, ou le *Bosco Bar*, au rez-de-chaussée du célèbre grand magasin *GUM*, ou bien le *City Space*, perché à 140 mètres au-dessus de Moscou avec une vue panoramique à 360° sur la ville.
Le choix est infini; mais ce livre se limite à 29 restaurants exclusifs, qui montrent que Moscou est une métropole à la mode avec une scène gastronomique des plus vivantes.

Katharina Feuer

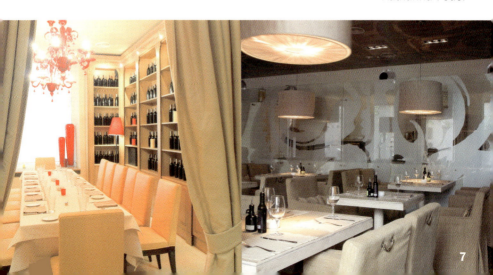

Introducción

Moscú se mueve sin pausa. Tras décadas monolíticas y grises le ha llegado la hora del color y la estridencia. Los artículos de consumo de occidente y las ideas comerciales e influencias de todo el mundo se van asentando en lo que es ya un país abierto.

La escena gastronómica es igualmente multicultural y activa; en esta metrópoli no hay nada que no se encuentre, ya sea lo asiático en *Vertinsky* o *Suzy Wong*, lo italiano de *Cantinetta Antinori* o *Bocconcino* o la propuesta india en *Indus*. Sin embargo los propietarios, nombres y diseño, cambian a veces tan deprisa, que incluso quienes conocen bien los innumerables restaurantes, bares y clubs llegan a perder las referencias. Algunos han podido sentar pautas, ya sea marcando modas, como *Galereya* o *Propaganda*, o convirtiéndose en clásicos, como *Gorki* o *Metropol*.

Numerosos arquitectos y diseñadores rusos recolectan estilos e impresiones de todo el mundo, los acentúan con la cultura y estética rusas y filtran aquello que encaje con Moscú, reinterpretando ideas según su propia concepción.

De ahí que a la hora de crear el diseño y el equipamiento se de rienda suelta tanto a la imaginación como al presupuesto. Uno de los admirables ejemplos es el restaurante *Le Duc*, cuyos interiores reviven una iglesia gótica, además de *Shinok*, con una pequeña granja de animales vivos que de vez en cuanto descentran a los clientes mientras disfrutan de las especialidades de Ucrania. En el café del mismo nombre la revista *Vogue* presenta a glamourosos modelos andróginos.

Alguno de los restaurantes se ganan el prestigio ya sólo por su especial ubicación; éste es el caso de *Moskovsky* en el *Hotel National*, con vistas al Kremlin, al igual que el *Bosco Bar*, ubicado en la planta baja de los famosos grandes almacenes *GUM* o el *City Space*, a 140 metros de altura y con 360° de vistas sobre la ciudad.

La propuesta es infinita, si bien en este libro se limita a 29 exclusivos restaurantes, muestra de que Moscú es una metrópoli atrayente que encierra una activa escena culinaria.

<div style="text-align:right">Katharina Feuer</div>

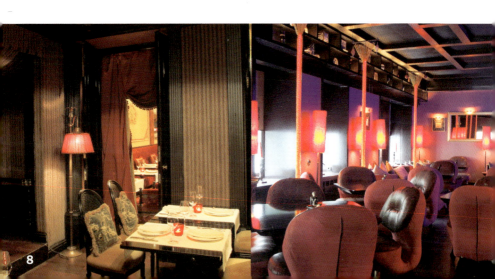

Introduzione

Mosca è una città in continua trasformazione: decenni di grigiore hanno lasciato il posto a una realtà vivace e colorata. Beni di consumo occidentali, idee commerciali e influssi provenienti da tutto il mondo stanno facendo il loro ingresso in questo paese ormai aperto.
Anche lo scenario gastronomico è multiculturale e dinamico: in questa metropoli si trova di tutto. Dalla cucina asiatica di ristoranti come il *Vertinsky* o il *Suzy Wong*, a quella italiana della *Cantinetta Antinori* o del *Bocconcino*, a quella indiana dell'*Indus*.
A volte, tuttavia, proprietari, nomi e design cambiano così rapidamente che anche per i conoscitori degli innumerevoli ristoranti, bar e club diventa difficile rimanere al passo con i continui mutamenti. Si affermano quei locali che riescono a fare tendenza, come il *Galereya* o il *Propaganda*, o che hanno una tradizione alle spalle, come il *Gorki* o il *Metropol*.
Molti architetti e designer russi raccolgono stili e impressioni da tutto il mondo e selezionano ciò che meglio si adatta a Mosca, utilizzando le idee secondo il proprio gusto e carattere, sotto l'influsso della cultura e del senso estetico russi.
Per questo motivo, in tema di design e di arredamento non vengono posti limiti alla fantasia e, talvolta, ai costi in termini di denaro. Unici nel loro genere sono il ristorante francese *Le Duc*, il cui interno ricorda una chiesa gotica, o lo *Shinok*, la cui piccola fattoria popolata di animali vivi distrae di tanto in tanto gli ospiti dalle specialità ucraine loro servite, mentre la rivista Vogue espone nell'omonimo Café le immagini patinate di modelle androgine.
Il successo di alcuni ristoranti si deve semplicemente alla loro speciale posizione, come nel caso del *Moskovsky*, situato all'interno dell'*Hotel National*, con vista sul Cremlino, o il *Bosco Bar*, al pianterreno del celebre grande magazzino *GUM*, o ancora il *City Space*, che si innalza su Mosca a un'altezza di 140 metri e regala un panorama a 360° sulla città.
La scelta è infinita. In questo libro, tuttavia, essa è limitata a 29 ristoranti esclusivi, testimonianza di una Mosca ormai metropoli alla moda, la cui gastronomia è in continua evoluzione.

Katharina Feuer

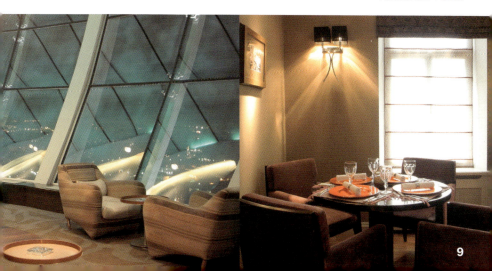

Biscuit

Design: Albina Nazimova | Chef: Andrei Tisyachnikov
Owner: Arkady Novikov

19 Ulitsa Kuznetsky Street, Building 1 | Moscow 107031 | Meshchanskoe
Phone: +7 495 925 1729
www.novikovgroup.ru
Metro: Kuznetsky Most
Opening hours: Sun–Thu noon to midnight, Fri–Sat noon to 1 am
Average price: $50
Cuisine: European, Asian
Special features: Regular visits by world-famous culinary stars–the likes of Alain Ducasse, Nobu Matsuhisa and Pierre Hermé

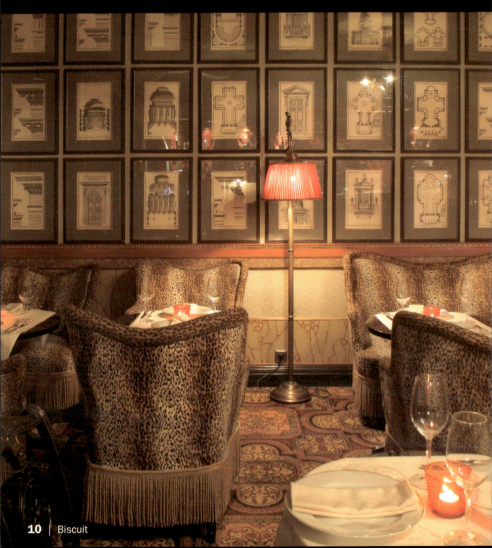

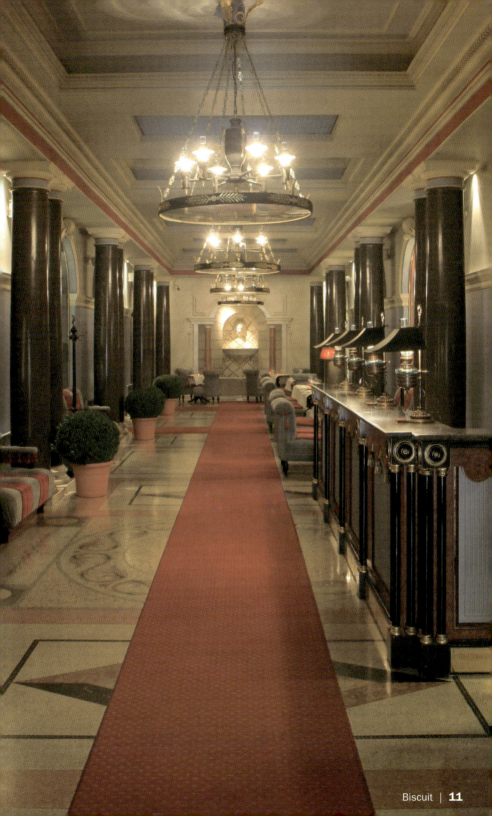

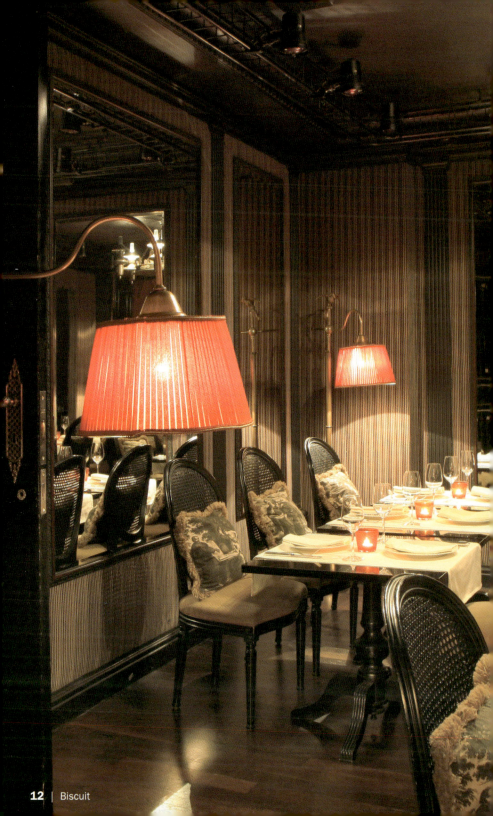

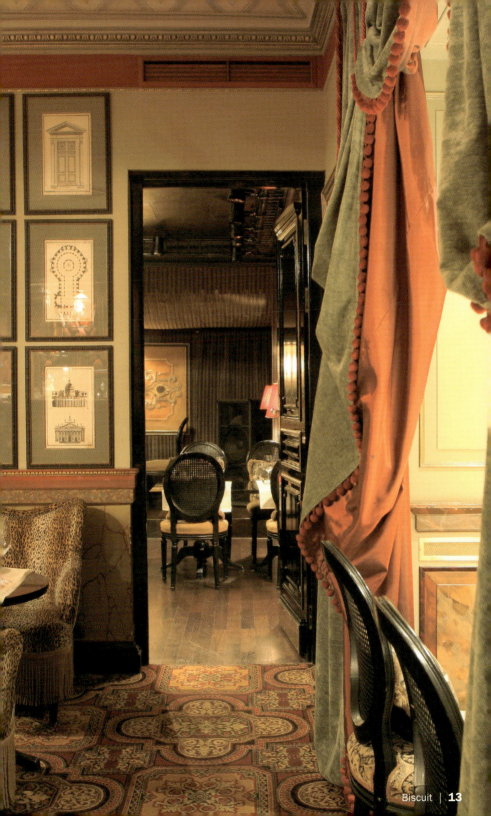

Red Mullet Fillets
on Tomato Jelly

Meerbarbenfilets auf Tomatengelee
Filets de rouget sur gelée de tomate
Salmonetes sobre gelatina de tomate
Filetti di triglia con gelatina di pomodoro

4 red mullet fillets, with skin
3 tbsp olive oil
1 tbsp chopped thyme
Salt, pepper

Marinate the red mullet fillets with the other ingredients for approx. 2 hours and sear on the skin side for 3 minutes.

6 oz tomatoes
2 leaves basil
2 leaves gelatin, soaked

Mash the tomatoes with the basil, season and heat up. Dissolve the gelatin in it, pour into a square container and chill for at least 4 hours.

8 oz tomatoes, seeded and skinned
1 tbsp olive oil
1 tsp brown sugar
1 tsp chopped parsley

Place all ingredients in a blender and mix until smooth. Season and chill.

1 ¾ oz mache
Cress and different herbs for decoration

To serve cut the jelly into the size of the red mullet and place on a tray. Divide the mache into individual leaves and place them on top of the jelly. Arrange the red mullet fillets on top of the mache and garnish with cress and herbs. Fill the tomato sauce in small bowls and place on the tray.

4 Meerbarbenfilets, mit Haut
3 EL Olivenöl
1 EL gehackter Thymian
Salz, Pfeffer

Die Meerbarbenfilets in den restlichen Zutaten ca. 2 Stunden marinieren und anschließend auf der Hautseite 3 Minuten braten.

180 g Tomaten
2 Basilikumblätter
2 Blatt Gelatine, eingeweicht

Die Tomaten mit dem Basilikum pürieren, abschmecken und erwärmen. Die Gelatine darin auflösen, in eine eckige Auflaufform geben und mindestens 4 Stunden kaltstellen.

240 g Tomaten, gehäutet und entkernt
1 EL Olivenöl
1 TL brauner Zucker
1 TL gehackte Petersilie

Alle Zutaten in einen Mixer geben und glatt mixen. Abschmecken und kaltstellen.

50 g Feldsalat
Kresse und verschiedene Kräuter zur Dekoration

Zum Anrichten das Gelee auf die Größe der Meerbarbenfilets zuschneiden und auf eine Platte legen. Den Feldsalat zerteilen und die einzelnen Blätter auf das Gelee legen. Die Meerbarbenfilets auf den Blättern arrangieren und mit Kresse und Kräutern garnieren. Die Tomatensauce in Schälchen füllen und auf die Platte stellen.

4 filets de rouget avec la peau
3 c. à soupe d'huile d'olive
1 c. à soupe de thym haché
Sel, poivre

Faire mariner les filets de rouget dans les autres ingrédients pendant env. 2 heures puis poêler côté peau pendant 3 minutes.

180 g de tomates
2 feuilles de basilique
2 feuilles de gélatine détrempées

Réduire les tomates en purée avec le basilique, assaisonner et réchauffer. Y dissoudre la gélatine, verser dans un moule carré et mettre au frais pendant au moins 4 heures.

240 g de tomates pelées et épépinées
1 c. à soupe d'huile d'olive
1 c. à café de sucre brun
1 c. à café de persil haché

Mettre tous les ingrédients dans un mixeur et mixer finement. Assaisonner et mettre au frais.

50 g de mâche
Cresson et herbes variées pour la décoration

Pour la présentation, couper des morceaux de gelée de la taille des filets et déposer sur un plat. Effeuiller la mâche et mettre les feuilles sur la gelée. Disposer les filets de rouget sur les feuilles et décorer avec le cresson et les herbes. Verser la sauce tomate dans de petites jattes placées sur le plat.

4 filetes de salmonete con piel
3 cucharadas de aceite de oliva
1 cucharada de tomillo picado
Sal y pimienta

Marinar los filetes de salmonete y el resto de los ingredientes durante 2 horas y a continuación freírlos en la sartén por el lado de la piel durante 3 minutos.

180 g de tomates
2 hojas de albahaca
2 láminas de gelatina remojada

Tamizar los tomates y la albahaca, salpimentarlos y calentarlos. Disolver la gelatina en la mezcla, verter ésta en un molde cuadrado y dejar enfriar durante 4 horas como mínimo.

240 g de tomates, pelados y despepitados
1 cucharada de aceite de oliva
1 cucharadita de azúcar moreno
1 cucharadita de perejil picado

Mezclar todos los ingredientes en la batidora. Aderezarlos y dejar enfriar.

50 g de canónigos
Berros y hierbas frescas para decorar

Cortar la gelatina del tamaño de los filetes de salmonete y colocarla en una bandeja. Distribuir los canónigos y colocar los berros sobre la gelatina. Poner los filetes de pescado sobre las hierbas y decorar con berros y hierbas frescas. Verter la salsa de tomate en pequeños cuencos y colocarlos sobre la bandeja.

4 filetti di triglia con la pelle
3 cucchiai di olio di oliva
1 cucchiaio di timo tritato
Sale, pepe

Marinare i filetti di triglia negli altri ingredienti per circa 2 ore, quindi arrostirli dalla parte della pelle per circa 3 minuti.

180 g di pomodori
2 foglie di basilico
2 fogli di gelatina ammorbiditi

Passare al passaverdura i pomodori e il basilico, condirli e riscaldarli. Scioglievi la gelatina, versare il tutto in uno stampo quadrato e mettere in frigo per almeno 4 ore.

240 g di pomodori, spellati e privati dei semi
1 cucchiaio di olio di oliva
1 cucchiaino di zucchero bruno
1 cucchiaino di prezzemolo tritato

Frullare tutti gli ingredienti fino ad ottenere un composto omogeneo. Regolare il condimento e mettere in frigo.

50 g di lattughella
Per la guarnizione: crescione ed erbe varie

Tagliare la gelatina adattando i pezzi alle dimensioni dei filetti e disporli su un piatto da portata. Dividere la lattughella e sistemare le foglie sulla gelatina. Appoggiare i filetti sulle foglie e guarnire con il crescione e le erbe. Versare la salsa di pomodoro in alcune scodelline e porre queste ultime sul piatto da portata.

Bocconcino

Design: Yuly Borisov | Chef: Kirill Karmalov | Owner: Mikchael Gohner

7 Strastnoy Boulevard, Building 1 | Moscow 103009 | Tverskoy
Phone: +7 495 299 7359
www.bocconcino.ru
Metro: Pushkinskaya, Chekhovskaya
Opening hours: Every day noon to midnight
Average price: $30
Cuisine: Italian
Special features: Wood-fired oven, noon to 5 pm–15% discount on entire menu, pizza prepared by Stefano Vitti, a third-generation pizzaiolo

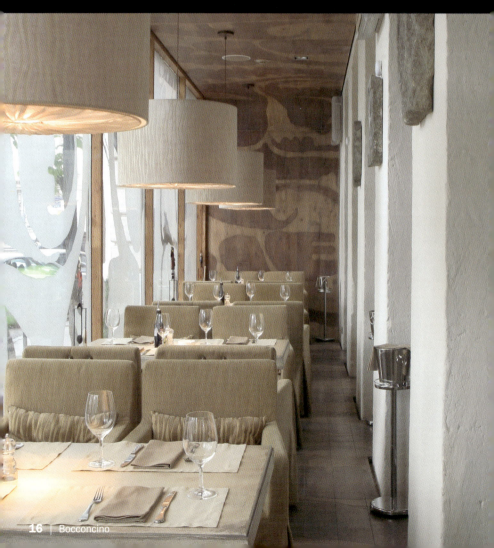

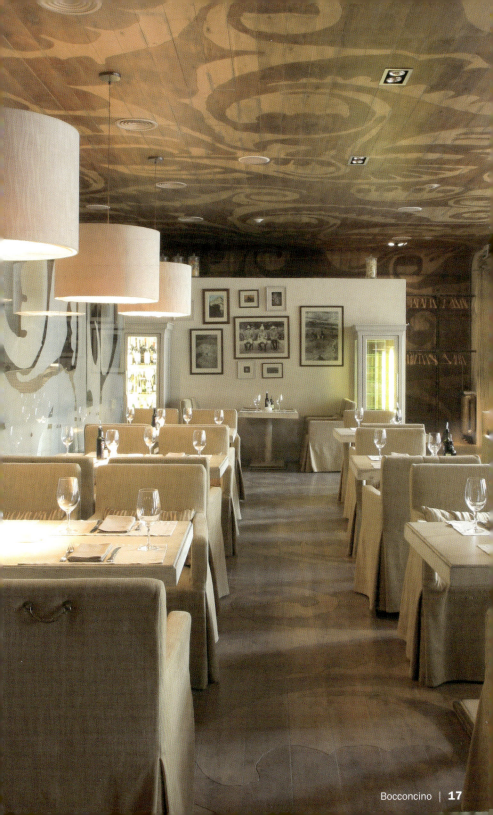

Bosco Bar

Design: Stramigioli Andrea, Sean Dix | **Chef:** Mariano Valerio
Owner: Bosco di Ciliegi

3 Red Square, Ground floor of GUM | Moscow 109012 | Red Square
Phone: +7 495 627 3703
www.bosco.ru
Metro: Okhotny Ryad, Teatralnaya
Opening hours: Every day 10 am to 11 pm
Average price: $60
Cuisine: Italian
Special features: Great view of Red Square and Kremlin

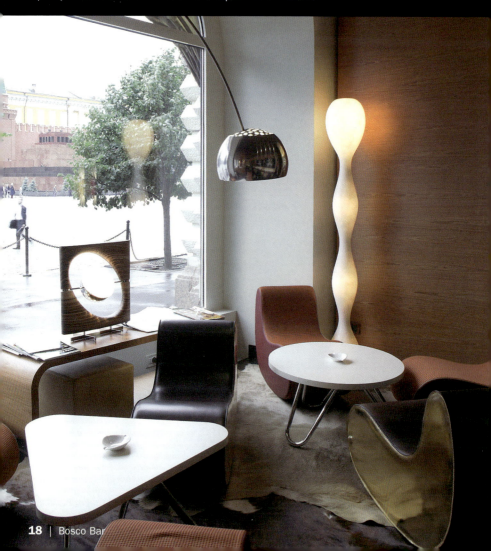

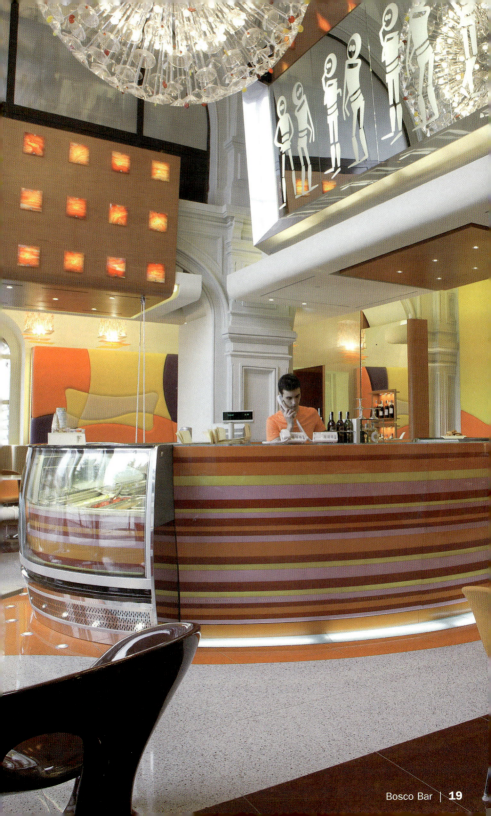

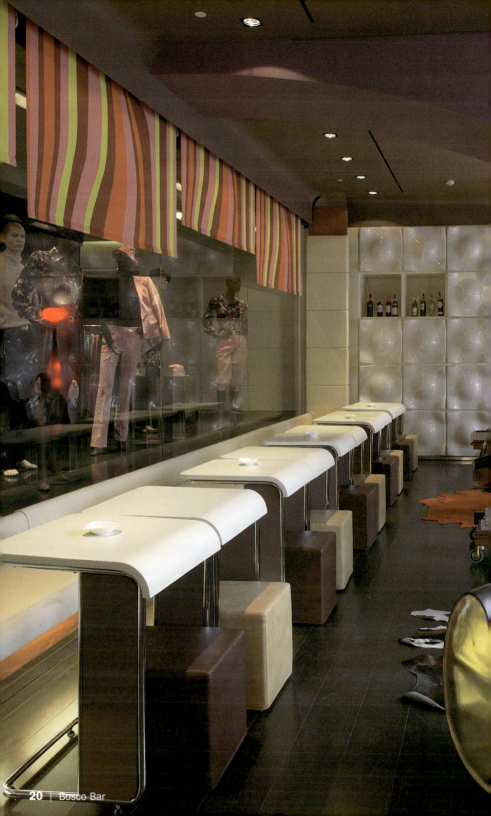

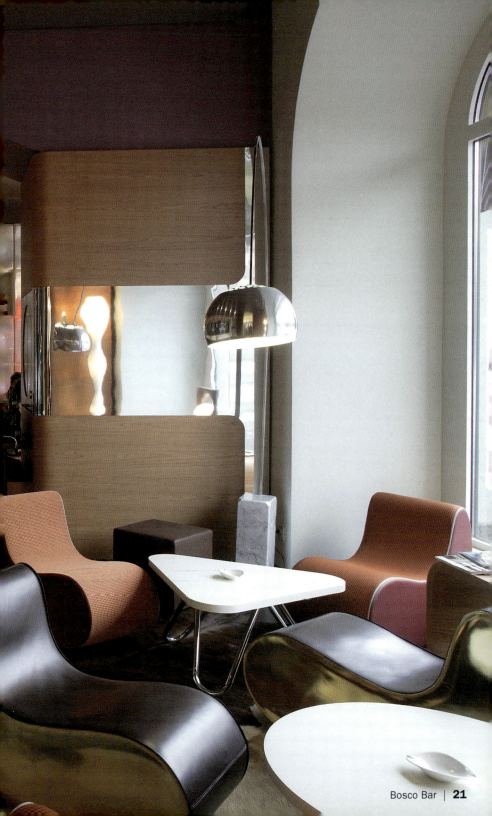

Cantinetta Antinori

Design: Nazimova Albina | Chef: Marko Zampieri
Owner: Arkady Novikov

20, Denezhny Lane | Moscow 119002 | Arbat
Phone: +7 495 241 3771, +7 495 241 3325
www.novikovgroup.ru
Metro: Smolenskaya
Opening hours: Every day noon to midnight
Average price: $70
Cuisine: Italian, Tuscan
Special features: Terrace, large wine collection, open kitchen

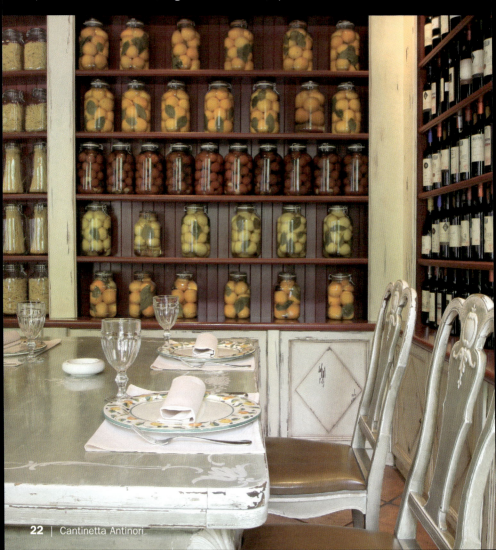

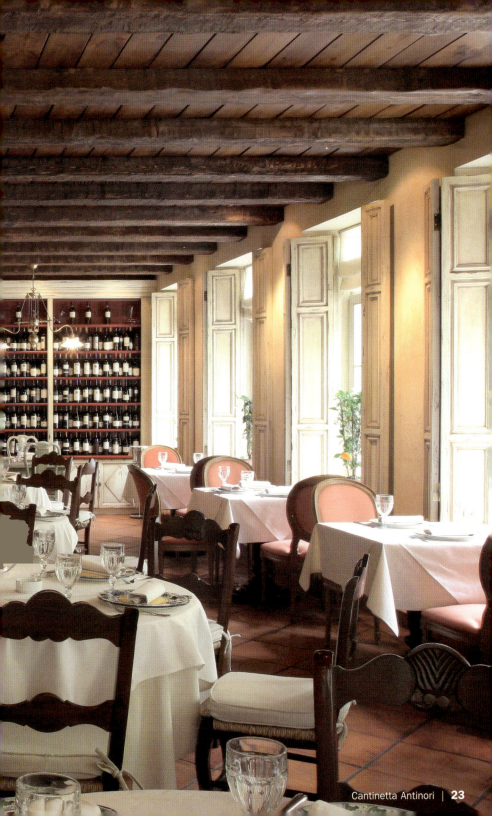

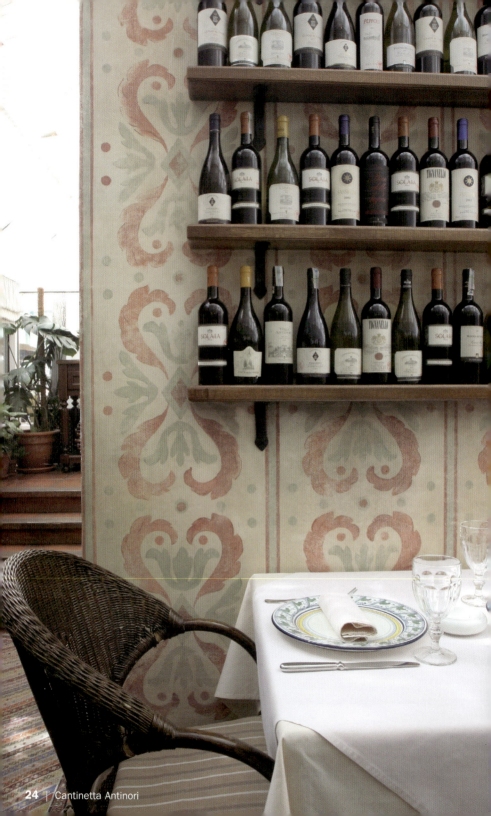

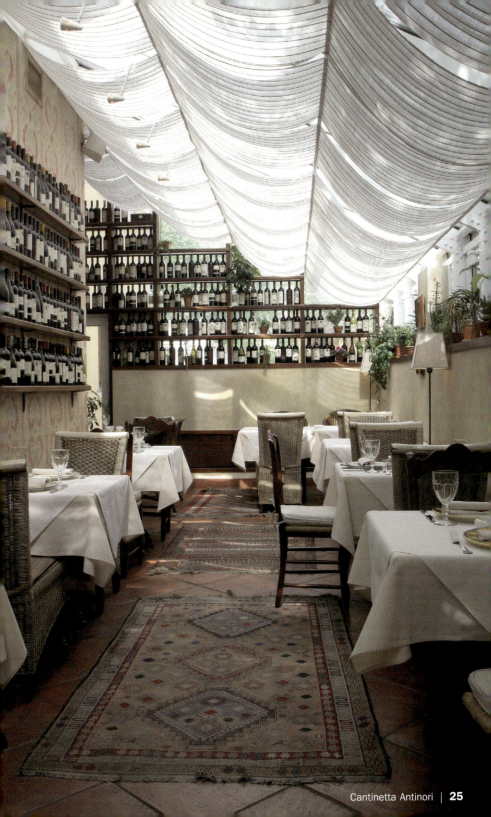

Beef Carpaccio with Truffle

Rindercarpaccio mit Trüffel
Carpaccio de bœuf à la truffe
Carpaccio de vacuno con trufas
Carpaccio di manzo con tartufi

8 oz beef fillet
7 oz lettuce
4 cherry tomatoes
Couple of celery leaves
3 ½ oz parmesan shavings
1 black truffle
Vinegar, olive oil
Salt, pepper

Place the beef fillet in the freezer for approx. 30 minutes, then cut into very thin slices.
Part the lettuce, wash, marinate with vinegar and oil and divide among four plates. Place the carpaccio on the lettuce, season with salt and pepper and garnish with cherry tomatoes, celery leaves, parmesan shavings and thinly sliced truffle.

240 g Rinderfilet
200 g Kopfsalat
4 Kirschtomaten
Einige Staudensellerieblätter
100 g Parmesanspäne
1 schwarzer Trüffel
Essig, Olivenöl
Salz, Pfeffer

Das Rinderfilet ca. 30 Minuten ins Gefrierfach geben, danach in sehr dünne Scheiben schneiden.
Den Kopfsalat zerteilen, waschen, mit Essig und Öl marinieren und auf vier Tellern verteilen. Das Carpaccio auf den Salat geben, mit Salz und Pfeffer würzen und mit Kirschtomaten, Sellerieblättern, Parmesanspänen und gehobeltem Trüffel garnieren.

240 g de filet de bœuf
200 g de laitue
4 tomates cocktail
Quelques feuilles de céleri branche
100 g de copeaux de parmesan
1 truffe noire
Vinaigre, huile d'olive
Sel, poivre

Mettre le filet de bœuf env. 30 minutes au freezer, le couper ensuite en très fines tranches.
Effeuiller la laitue, la laver, assaisonner de vinaigre et d'huile et répartir sur quatre assiettes.
Disposer le carpaccio sur la salade, saler, poivrer et garnir de tomates cocktail, de feuilles de céleri, de copeaux de parmesan et de lamelles de truffe.

240 g de carne de vacuno
200 g de lechuga
4 tomates cereza
Unas hojas de apio
100 g de virutas de parmesano
1 trufa negra
Vinagre, aceite de oliva
Sal y pimienta

Conservar la carne de vacuno en el congelador durante 30 minutos aprox. y a continuación cortarla en rodajas muy finas.
Lavar y cortar la lechuga, aderezarla con aceite y vinagre y distribuirla en cuatro platos. Colocar el carpaccio sobre la lechuga, salpimentarlo y decorarlo con los tomates, las hojas de apio, las virutas de parmesano y la trufa laminada.

240 g di filetto di manzo
200 g di lattuga
4 pomodori pachini
Foglie di sedano
100 g di scaglie di parmigiano
1 tartufo nero
Aceto, olio d'oliva
Sale, pepe

Mettere il filetto di manzo nel congelatore per circa 30 minuti, quindi tagliarlo a fette sottilissime.
Dividere la lattuga, lavarla, marinarla in olio e aceto e ripartirla in quattro piatti. Disporre il carpaccio sull'insalata, salare, pepare e guarnire con pomodori pachini, foglie di sedano e scaglie di parmigiano e di tartufo.

City Space Bar & Lounge

Design: BBG-BBGM | Owner: Swissôtel Hotels & Resorts

52, Kosmodamianskaya Embankment, Building 6, 34th floor | Moscow 115054
Zamoskvorechye
Phone: +7 495 787 9800
www.moscow.swissotel.com
Metro: Paveletskaya
Opening hours: Every day 5 pm to 3 am
Average price: $50
Cuisine: Cocktails, variety of hot and cold dishes
Special features: 360-degree panoramic view over Moscow skyline from 140 meters up in the 34th floor of Swissôtel Krasnye Holmy Moscow

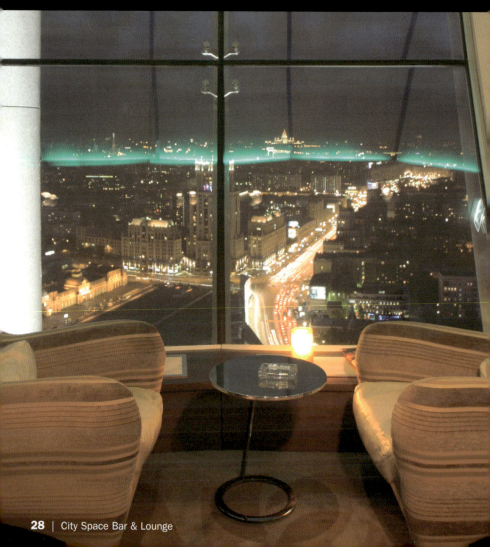

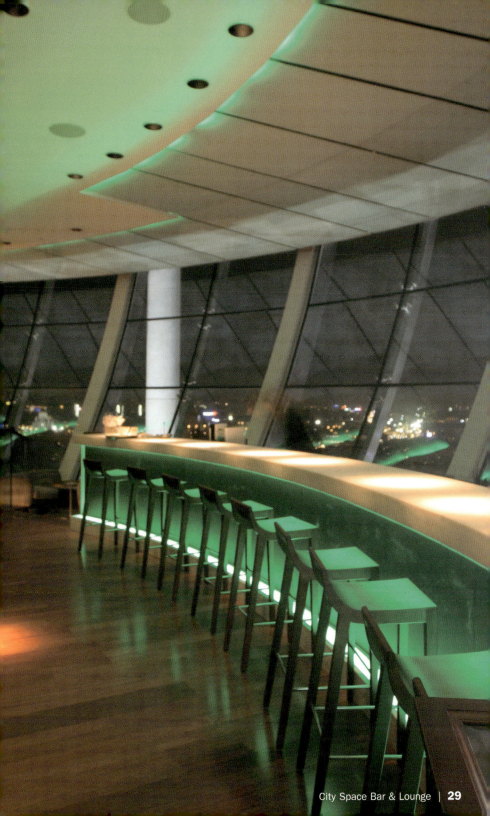

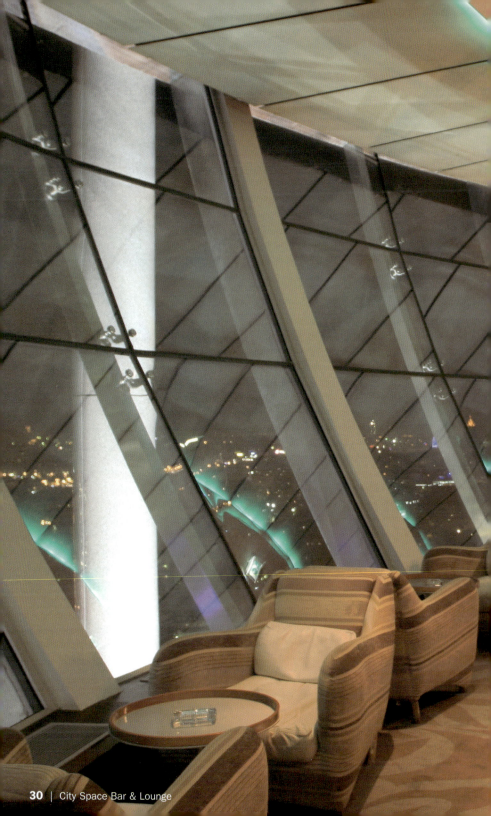

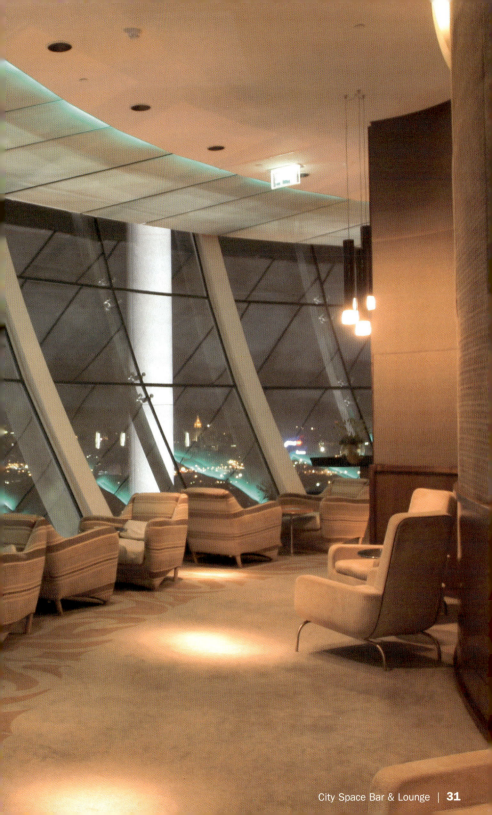

Dolf

Design: Dolf Michel | Chef & Owner: Roman Lender

1, Smolenskiy Lane, Building 3/2 | Moscow 121091 | Arbat
Phone: +7 495 241 6271
Metro: Smolenskaya
Opening hours: Every day noon to midnight
Average price: $50
Cuisine: Mediterranean fusion
Special features: Changing art exhibitions

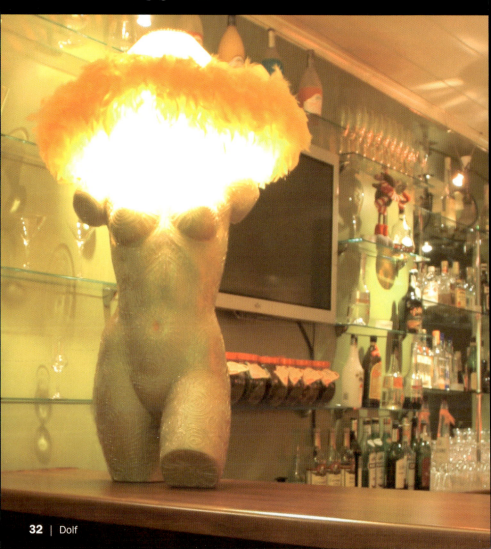

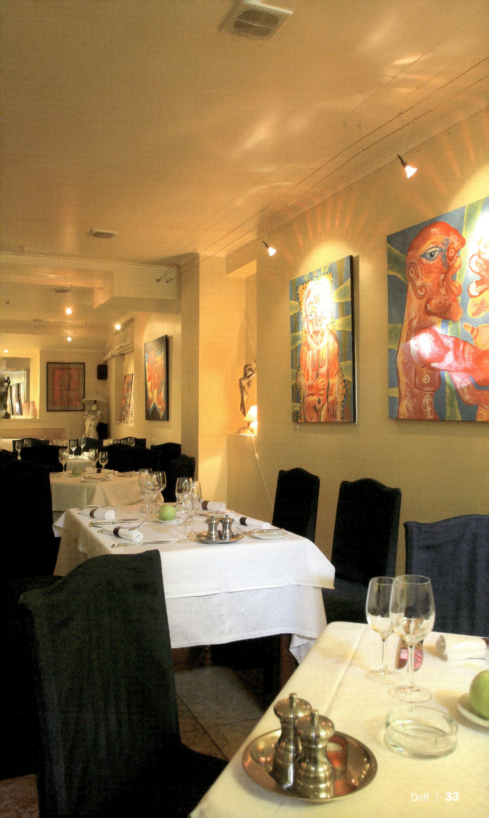

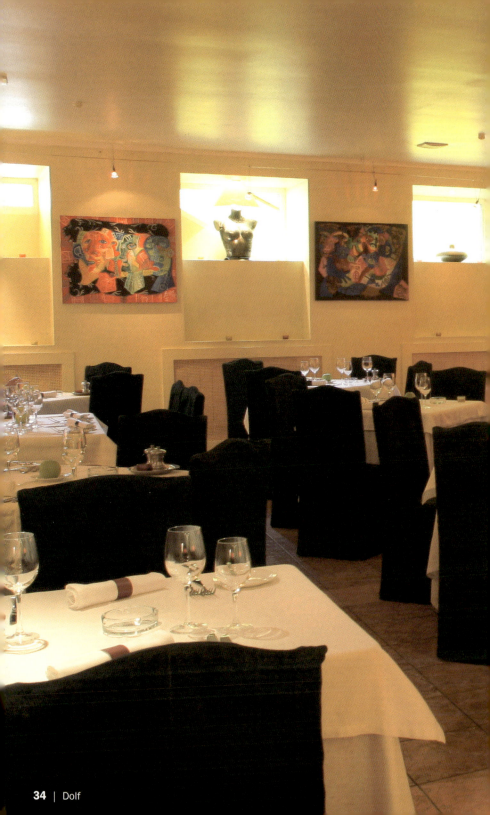

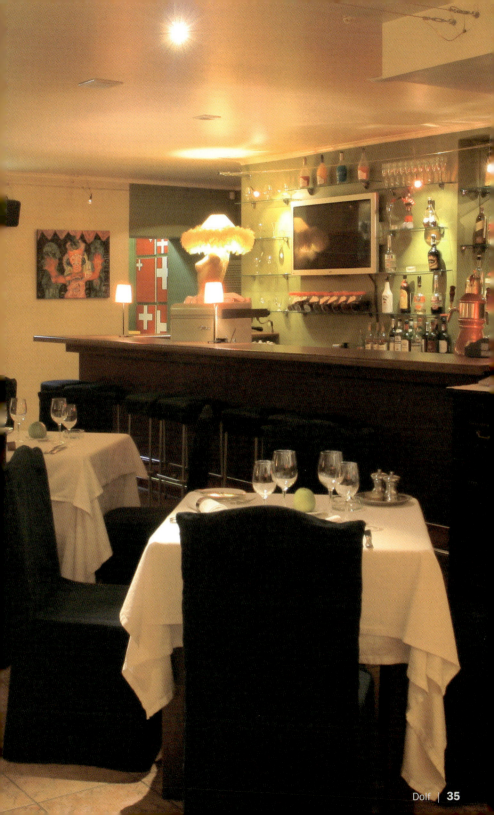

Seared Foie Gras
with Cocoa and Apples

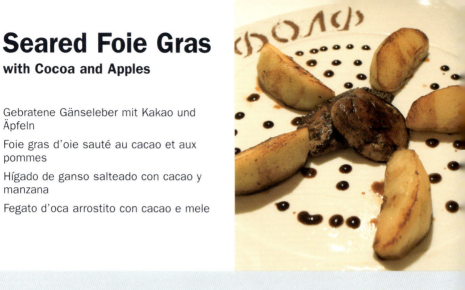

Gebratene Gänseleber mit Kakao und Äpfeln

Foie gras d'oie sauté au cacao et aux pommes

Hígado de ganso salteado con cacao y manzana

Fegato d'oca arrostito con cacao e mele

8 slices foie gras, 1 oz each, cleaned
Salt, pepper
Cacoa powder
2 tbsp butter

2 green apples
100 ml balsamic vinegar
1 tbsp sugar

Peel the apples, cut into wedges and remove the core. Bring the vinegar and the sugar to a boil and cook the apple wedges until tender.
Season the foie gras slices, toss in cocoa and sear in butter for 1 minute on both sides.
Place two slices of foie gras in the middle of each plate, put five apple wedges around them and garnish with balsamic-reduction.

8 Scheiben Gänsestopfleber, à 30 g, geputzt
Salz, Pfeffer
Kakaopulver
2 EL Butter

2 grüne Äpfel
100 ml Balsamico-Essig
1 EL Zucker

Die Äpfel schälen, in Spalten schneiden und das Kerngehäuse entfernen. Den Essig mit dem Zucker aufkochen und die Apfelspalten bissfest garen.
Die Gänseleberscheiben würzen, in Kakao wälzen und in der Butter von beiden Seiten 1 Minute anbraten.
Jeweils zwei Scheiben Gänseleber in die Mitte des Tellers legen, fünf Apfelspalten darum verteilen und mit der Balsamico-Reduktion garnieren.

8 tranches de foie gras d'oie nettoyé, de 30 g chacune
Sel, poivre
Poudre de cacao
2 c. à soupe de beurre

2 pommes vertes
100 ml de vinaigre balsamique
1 c. à soupe de sucre

Peler les pommes, les couper en quartiers et enlever les pépins. Bouillir le vinaigre avec le sucre et cuire les quartiers de pomme al dente.
Saler et poivrer les tranches de foie gras d'oie, les rouler dans le cacao et les poêler dans le beurre 1 minute de chaque côté.
Placer deux tranches de foie gras au milieu de chaque assiette, répartir autour cinq quartiers de pomme et décorer avec la réduction de vinaigre balsamique.

8 rodajas limpias de hígado de ganso de 30 g
Sal y pimienta
Cacao en polvo
2 cucharadas de mantequilla

2 manzanas verdes
100 ml de vinagre balsámico
1 cucharada de azúcar

Pelar las manzanas, cortarlas en trozos y quitarles el corazón. Cocer el vinagre con el azúcar y rehogar en la mezcla las manzanas hasta que estén hechas.
Sazonar las rodajas de hígado de ganso, empanarlas en el cacao y saltearlas en mantequilla por ambos lados durante 1 minuto.
Disponer respectivamente dos rodajas de hígado de ganso en cada plato, repartir cinco trozos de manzana alrededor y rociar con la reducción del vinagre balsámico.

8 fette di foie gras di 30 g ciascuna, pulite
Sale, pepe
Cacao in polvere
2 cucchiai di burro

2 mele verdi
100 ml di aceto balsamico
1 cucchiaio di zucchero

Sbucciare le mele, tagliarle a spicchi e privarle del torsolo. Portare ad ebollizione l'aceto e lo zucchero e cuocervi al dente gli spicchi di mela.
Condire le fette di foie gras, passarle nel cacao e rosolarle nel burro per 1 minuto da entrambi i lati.
Mettere al centro di ciascun piatto due fette di foie gras, disporvi attorno cinque spicchi di mela e guarnire con l'aceto balsamico ristretto.

Galereya

Design: Studio 69 | Chef: Uilliam Lamberti
Owner: Novikov Restaurant Group

27, Petrovka Street | Moscow 107031 | Tverskoe
Phone: +7 495 937 4544, +7 495 937 4504
www.novikovgroup.ru
Metro: Pushkinskaya, Tverskaya
Opening hours: Every day, 24 hours
Average price: $60
Cuisine: European, Asian
Special features: Contemporary art exhibitions–programme change every 3 weeks, music and dance parties most weekends

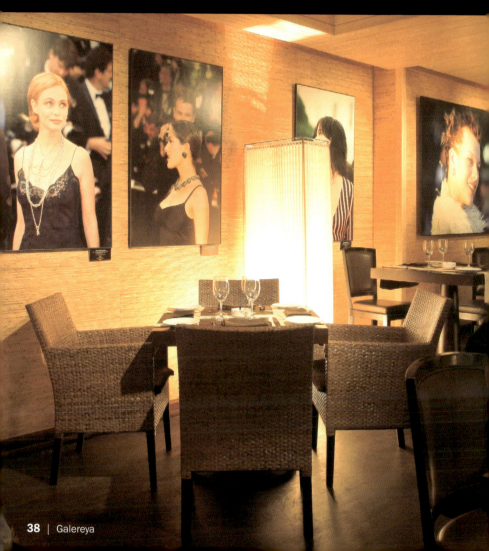

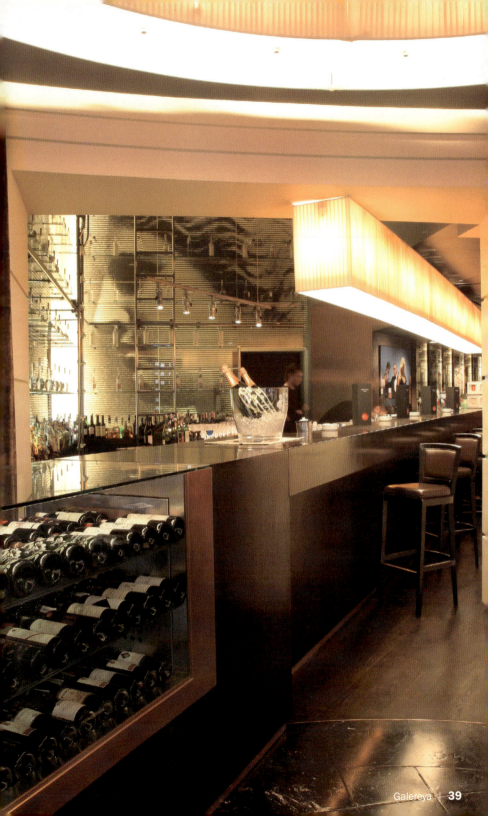

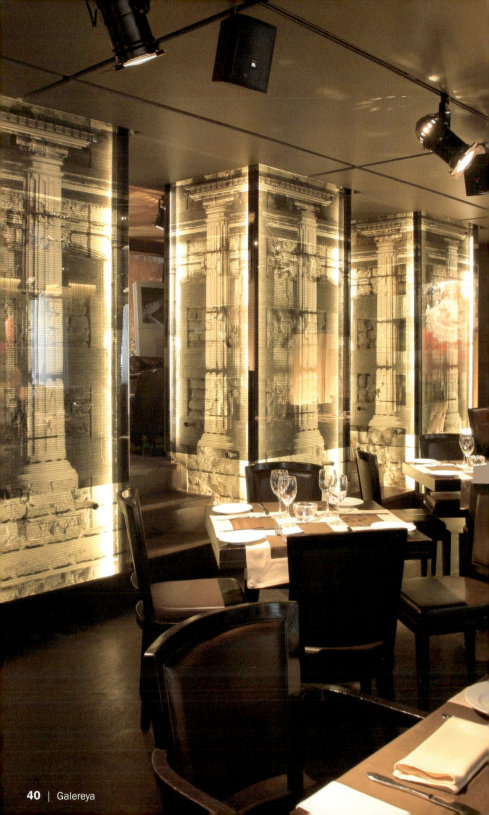

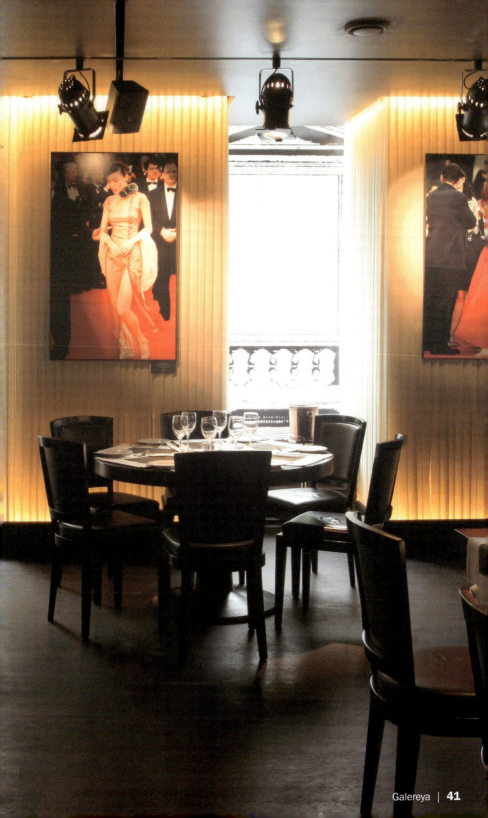

Scallop Skewer

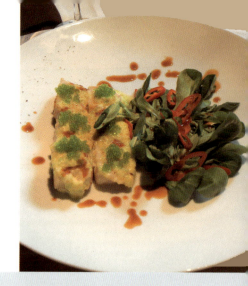

Jakobsmuschelspieß
Brochette de coquilles Saint-Jacques
Brocheta de vieiras
Spiedini di capesante

24 scallops
6 tbsp Japanese mayonnaise (e.g. Kewpie)
1 tsp olive oil
2 tbsp green sea urchin roe
1 tsp ginger, chopped
1 tbsp chives, chopped

7 oz mache
Salt, pepper, vinegar, oil
2 red chilies, in fine rings

Place 3 scallops on each skewer, brush with 4 tbsp mayonnaise and sear at 360 °F for approx. 3–4 minutes until golden brown.
Mix 2 tbsp mayonnaise with olive oil, sea urchin roe, ginger and chives and brush the skewers with the mixture.
Clean and wash the mache and marinate with salt, pepper, vinegar and oil.
Place two skewers on each plate, put the salad beside them and garnish with chili rings and a little vinaigrette.

24 Jacobsmuscheln
6 EL japanische Mayonnaise (z.B. Kewpie)
1 TL Olivenöl
2 EL grüner Seeigelrogen
1 TL Ingwer, gehackt
1 EL Schnittlauch, geschnitten

200 g Feldsalat
Salz, Pfeffer, Essig, Öl
2 rote Chilischoten, in feinen Ringen

Jeweils 3 Jakobsmuscheln auf einen Spieß stecken, mit 4 EL Mayonnaise bestreichen und bei 180 °C ca. 3–4 Minuten goldbraun braten.
2 EL Mayonnaise mit dem Olivenöl, dem Seeigelrogen, dem Ingwer und Schnittlauch mischen und die gegarten Spieße damit bestreichen.
Den Feldsalat putzen, waschen und mit Salz, Pfeffer, Essig und Öl marinieren.
Jeweils zwei Spieße auf einen Teller geben, den Salat daneben setzen und mit den Chiliringen und etwas Salatdressing garnieren.

24 coquilles Saint-Jacques
6 c. à soupe de mayonnaise japonaise
(par ex. Kewpie)
1 c. à café d'huile d'olive
2 c. à soupe d'œufs d'oursin vert
1 c. à café de gingembre haché
1 c. à soupe de ciboulette coupée

200 g de mâche
Sel, poivre, vinaigre, huile
2 piments rouges en fines rondelles

Embrocher respectivement 3 coquilles Saint-Jacques sur une brochette, les badigeonner avec 4 c. à soupe de mayonnaise et les faire dorer à 180 °C env. 3–4 minutes.
Mélanger 2 c. à soupe de mayonnaise avec l'huile d'olive, les œufs d'oursin, le gingembre et la ciboulette et en tartiner les brochettes cuites.
Nettoyer et laver la mâche, saler, poivrer et assaisonner de vinaigre et d'huile.
Déposer deux brochettes sur chaque assiette, placer la salade à côté et garnir de rondelles de piment avec un peu de sauce de salade.

24 vieiras
6 cucharadas de mahonesa japonesa
(p.ej. Kewpie)
1 cucharadita de aceite de oliva
2 cucharadas de huevas verdes de erizo de mar
1 cucharadita de jengibre picado
1 cucharada de cebollino cortado

200 g de canónigos
Sal, pimienta, aceite y vinagre
2 de chiles rojos picados en aros finos

Insertar tres vieiras en cada brocheta, untarlas con 4 cucharadas de mahonesa y dorarlas al horno a 180 °C durante 3–4 minutos aprox.
Mezclar 2 cucharadas de mahonesa con el aceite de oliva, las huevas de erizo de mar, el jengibre y el cebollino y untar con la mezcla las brochetas ya doradas.
Limpiar y lavar los canónigos y aliñarlos con sal, pimienta, aceite y vinagre.
Disponer dos brochetas en cada plato, colocar la ensalada al lado y decorar con los aros de chiles y algo de aliño de la ensalada.

24 capesante
6 cucchiai di maionese giapponese
(ad es. Kewpie)
1 cucchiaino di olio d'oliva
2 cucchiai di uova di riccio di mare
1 cucchiaino di zenzero tritato
1 cucchiaio di erba cipollina sminuzzata

200 g di lattughella
Sale, pepe, aceto, olio
2 peperoncini rossi tagliati ad anelli sottili

Infilzare 3 capesante su ciascuno spiedino, spennellarle con 4 cucchiai di maionese e dorarle a 180 °C per circa 3–4 minuti.
Mescolare 2 cucchiai di maionese con l'olio d'oliva, le uova di riccio di mare e lo zenzero, quindi stendere il composto sugli spiedini già cotti.
Pulire la lattughella, lavarla e marinarla in sale, pepe, aceto e olio.
Disporre due spiedini in ciascun piatto, disporvi attorno l'insalata e guarnire con gli anelli di peperoncino e del dressing.

Garage

Design: Braude Dmitry | Chef: Dimitry Shaburov

16/2 Tverskaya Street, Pushkinskay Square | Moscow 125009 | Tverskoe
Phone: +7 495 209 1848
www.garageclub.ru
Metro: Pushkinskaya, Tverskaya, Chekhovskaya
Opening hours: Every day, 24 hours
Average price: $30
Cuisine: International, Japanese
Special features: Celebrity & after-party hangout, chilled dancing

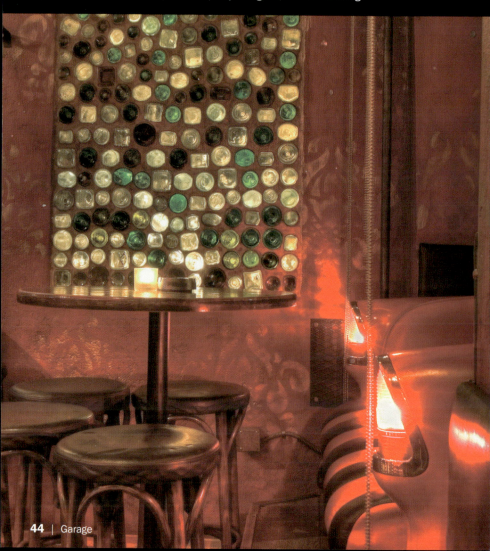

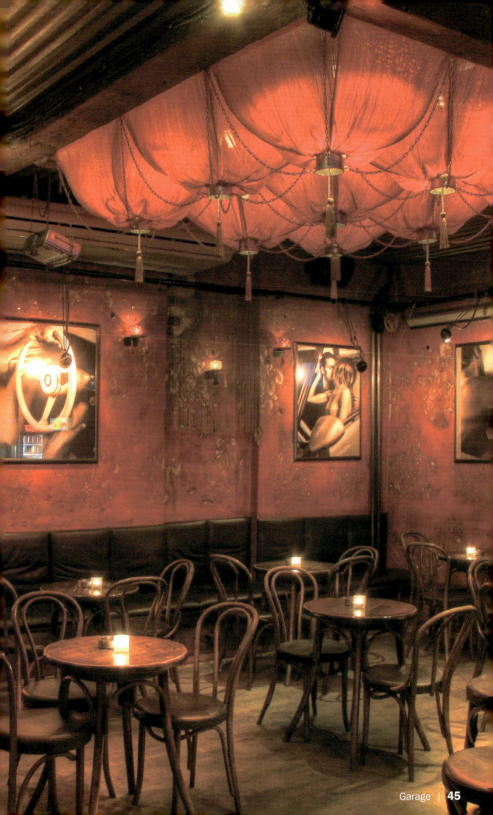

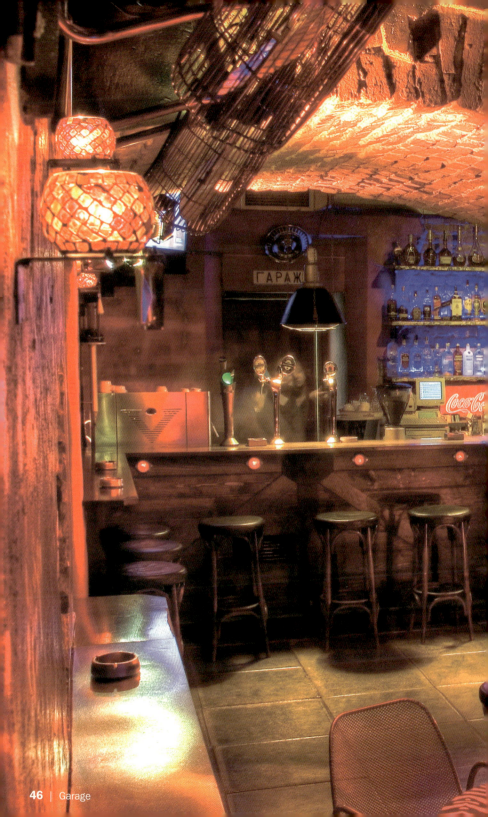

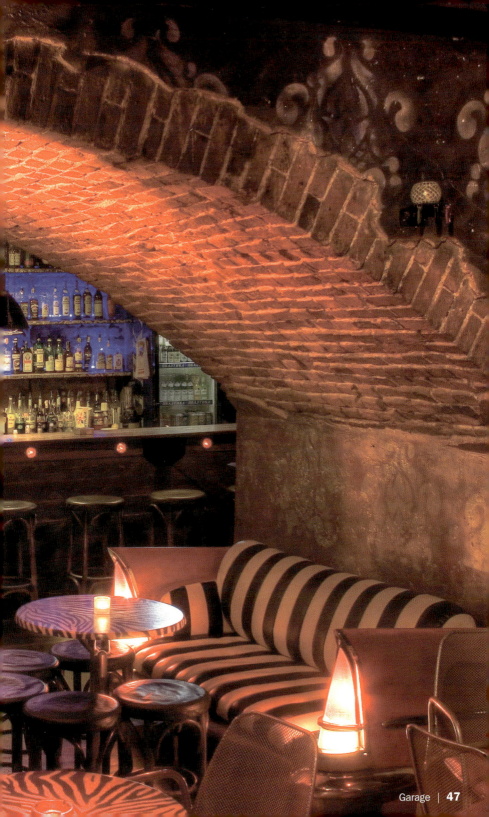

Genatsvale VIP

Design: A. Svanidze | Chef: Khinikadze ZaZa | Owner: Markosiya M.S.

14/2, Ostozhenka | Moscow 119034 | Khamovniki
Phone: +7 495 203 1242
Metro: Kropotkinskaya
Opening hours: Every day noon to midnight
Average price: $50
Cuisine: Georgian
Special features: Every day, 7 pm to midnight, guests are entertained with Georgian polyphonic singing and fiery folk dances

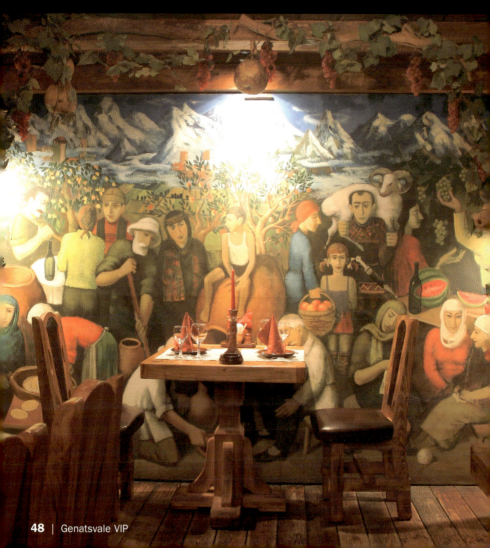

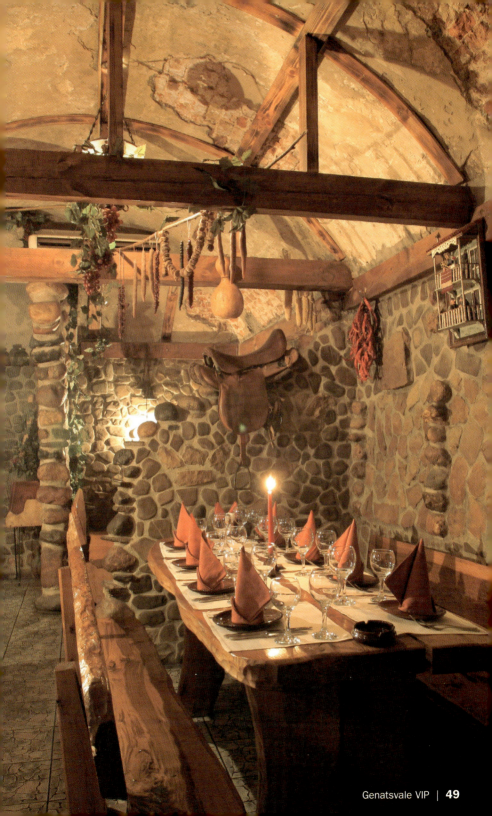

Gorki

Chef & Owner: Eric Balan

3, 1st Tverskaya-Yamskaya Street | Moscow 125047 | Tverskoe
Phone: +7 495 251 5626, +7 495 775 2456
www.gorki.su
Metro: Mayakovskaya
Opening hours: Every day 11 am to last guest
Average price: $90
Cuisine: Mediterranean, Russian
Special features: Even in Soviet times there was luxury, but only the elite could enjoy it

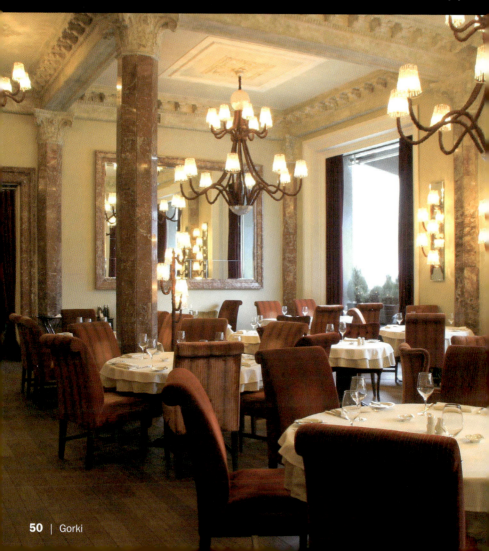

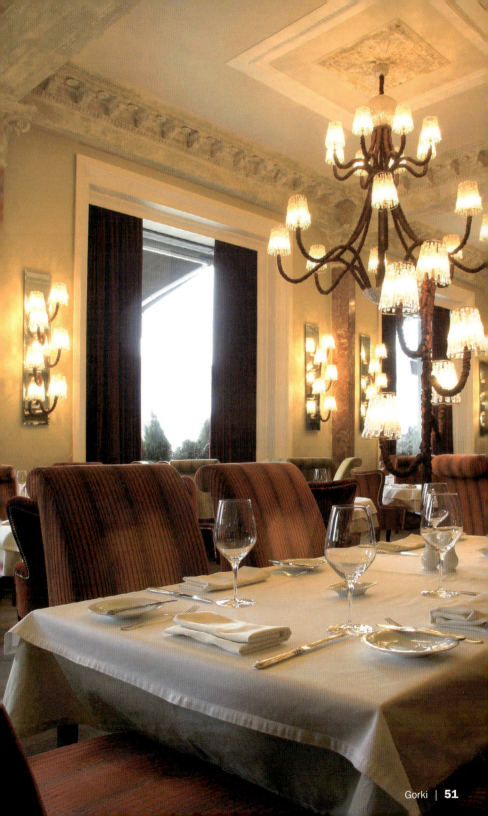

Indus

Design & Owner: Stepan Mikhalkov
Chef: Vineet Bhatia, Mallikarjun Goud

15, Plotnikov Lane | Moscow 121002 | Khamovniki
Phone: +7 495 244 7979
www.eatout.ru
Metro: Smolenskaya, Kropotkinskaya
Opening hours: Every day noon to midnight
Average price: $60
Cuisine: Modern Indian
Special features: First restaurant in Russia to serve modern Indian cuisine

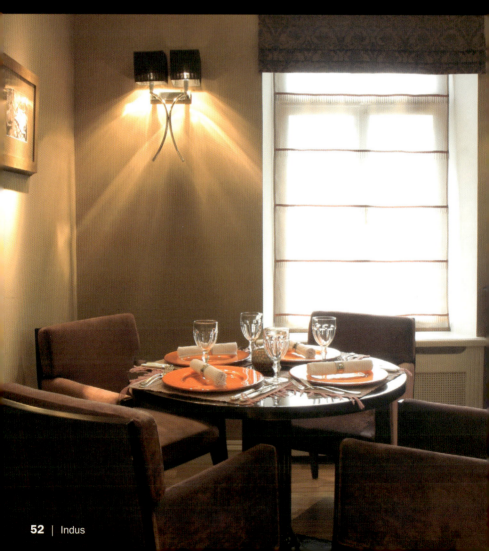

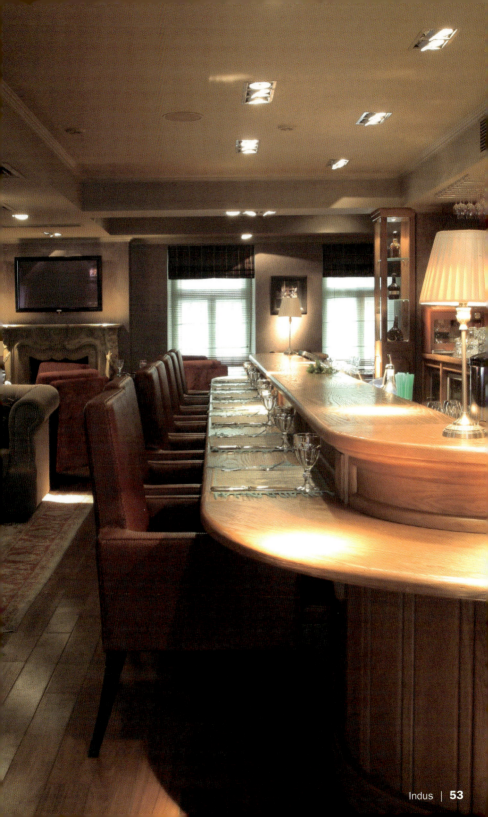

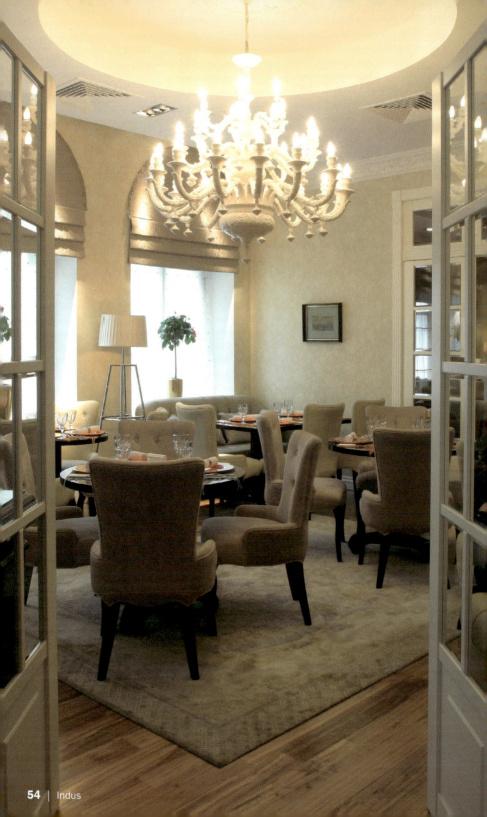

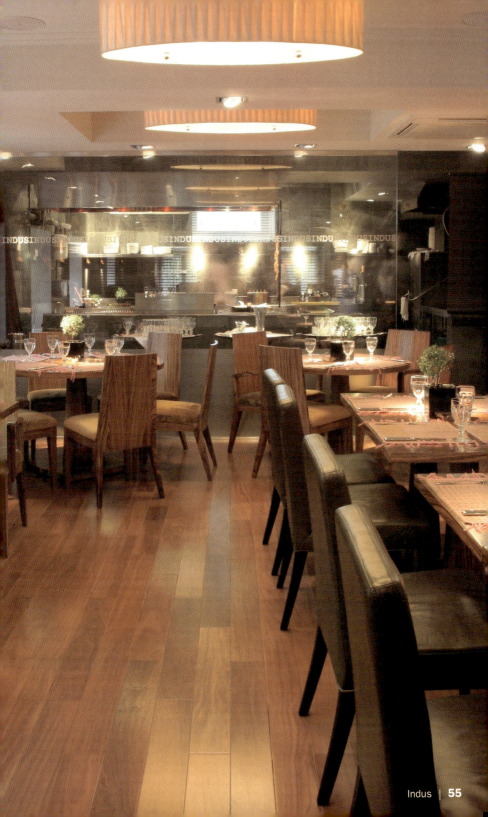

Smoked Tandoori-Salmon

Geräucherter Tandoori-Lachs
Saumon fumé tandoori
Salmón ahumado Tandoori
Salmone affumicato alla Tandoori

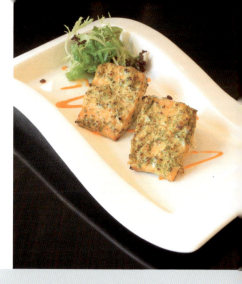

1 lb 9 oz salmon fillet with skin
2 tbsp coarse Pommery-mustard
2 tbsp thick yogurt
4 tbsp honey
1 tbsp dill, chopped
1 tbsp cilantro leaves, chopped
1 tsp ginger, chopped
5 green chilies, chopped
1 tsp turmeric
1 tsp chili powder
60 ml olive oil
Salt

Cut the salmon into 8 squares. Combine the other ingredients and marinate the salmon over night. Then rinse off the marinade and dry the salmon off.

3 tbsp wood shavings for smoking
4 cloves
2 cardamom buds
1 tbsp melted butter

Place the wood shavings in a large pot, heat on large flame, until the shavings start smoking, add the herbs and butter and place the salmon on a plate on top of the shavings. Remove from heat and cover with a tight closing lid. Smoke for 3 hours.

2 tbsp butter
4 tbsp mayonnaise
1 tbsp chopped dill

Sear the salmon from both sides in butter and serve with dill-mayonnaise.

720 g Lachsfilet mit Haut
2 EL grober Pommery-Senf
2 EL dickflüssiger Joghurt
4 EL Honig
1 EL Dill, gehackt
1 EL Korianderblätter, gehackt
1 TL Ingwer, gehackt
5 grüne Chilischoten, gehackt
1 TL Kurkuma
1 TL Chilipulver
60 ml Olivenöl
Salz

Den Lachs in 8 rechteckige Stücke schneiden. Die restlichen Zutaten mischen und den Lachs darin über Nacht marinieren. Anschließend die Marinade abspülen und den Lachs abtrocknen.

3 EL Holzspäne zum Räuchern
4 Nelken
2 Kardamomkapseln
1 EL geschmolzene Butter

Die Holzspäne in einen großen Topf geben, auf großer Flamme erhitzen, bis die Späne anfangen zu rauchen, die Gewürze und die Butter zugeben und den Lachs auf einem Teller auf die Späne stellen. Von der Flamme nehmen und mit einem dicht schließenden Deckel bedecken. 3 Stunden räuchern.

2 EL Butter
4 EL Mayonnaise
1 EL gehackter Dill

Den Lachs von beiden Seiten in Butter anbraten und mit der Dill-Mayonnaise servieren.

720 g de filet de saumon avec la peau
2 c. à soupe de moutarde Pommery à l'ancienne
2 c. à soupe de yaourt consistant
4 c. à soupe de miel
1 c. à soupe d'aneth haché
1 c. à soupe de feuilles de coriandre hachées
1 c. à café de gingembre haché
5 piments verts hachés
1 c. à café de curcuma
1 c. à café de poudre de piment
60 ml d'huile d'olive
Sel
Couper le saumon en 8 morceaux rectangulaires. Mélanger les autres ingrédients et y faire mariner le saumon une nuit. Enlever alors la marinade et essuyer le saumon.

3 c. à soupe de copeaux de bois pour le fumage
4 clous de girofle
2 capsules de cardamome
1 c. à soupe de beurre fondu
Mettre les copeaux de bois dans un grand faitout, réchauffer à feu vif jusqu'à ce que les copeaux commencent à fumer, ajouter les épices et le beurre et placer une assiette contenant le saumon sur les copeaux. Retirer du feu et couvrir hermétiquement avec un couvercle. Fumer pendant 3 heures.

2 c. à soupe de beurre
4 c. à soupe de mayonnaise
1 c. à soupe d'aneth haché
Faire revenir le saumon des deux côtés dans le beurre et servir avec la mayonnaise à l'aneth.

720 g de filetes de salmón con piel
2 cucharadas de mostaza en grano de Pommery
2 cucharadas de yogur espeso
4 cucharadas de miel
1 cucharada de eneldo picado
1 cucharada de hojas de cilantro picado
1 cucharadita de jengibre picado
5 chiles verdes picados
1 cucharadita de cúrcuma
1 cucharadita de chile en polvo
60 ml de aceite de oliva
Sal
Cortar el salmón en 8 rodajas rectangulares. Hacer una marinada con el resto de los ingredientes y dejar en ella el salmón durante una noche. A continuación quitar la marinada y secar el pescado.

3 cucharadas de virutas de madera para ahumar
4 clavos
2 semillas de cardamon
1 cucharada de mantequilla derretida
Meter las virutas en una cazuela grande y calentarlas a fuego fuerte hasta que comiencen a echar humo. Añadir las especias y la mantequilla y colocar el salmón en un plato sobre las virutas. Separarlas del fuego y cubrirlas con una tapadera hermética. Ahumar durante 3 horas.

2 cucharadas de mantequilla
4 cucharadas de mahonesa
1 cucharada de eneldo picado
Freír el salmón en mantequilla por ambos lados y servirlo con la mahonesa de eneldo.

720 g di filetto di salmone con la pelle
2 cucchiai di senape Pommery a grani grossi
2 cucchiai di yogurt denso
4 cucchiai di miele
1 cucchiaio di dragoncello tritato
1 cucchiaio di foglie di coriandolo tritate
1 cucchiaio di zenzero tritato
5 peperoncini verdi tritati
1 cucchiaino di curcuma
1 cucchiaino di peperoncino in polvere
60 ml di olio di oliva
Sale
Tagliare il salmone in 8 tranci quadrati. Mescolare gli altri ingredienti e marinarvi il salmone per una notte, quindi eliminare la marinata e asciugare il salmone.

Per affumicare: 3 cucchiai di trucioli di legno
4 chiodi di garofano
2 semi di cardamomo
1 cucchiaio di burro fuso
Mettere i trucioli in una grossa pentola e riscaldarli a fuoco ardito finché non iniziano a fumare. Unire gli aromi e il burro, porre il salmone su di un piatto e quindi sui trucioli. Toglierlo dal fuoco e coprirlo con un coperchio che chiuda bene. Affumicare per 3 ore.

2 cucchiai di burro
4 cucchiai di maionese
1 cucchiaio di dragoncello tritato
Rosolare il salmone nel burro da entrambi i lati e servirlo con la maionese al dragoncello.

Le Duc

Design: Andrey Dellos, Alexandr Popov | Chef: Michel Del Burgo
Owner: Andrey Dellos

2, 1905 Goda Street | Moscow 123100| Presnenskoe
Phone: +7 495 255 0390
www.leduc.ru
Metro: Ulitca 1905 Goda
Opening hours: Every day noon to midnight
Average price: $70
Cuisine: French
Special features: Dining in the atmosphere of a medieval castle

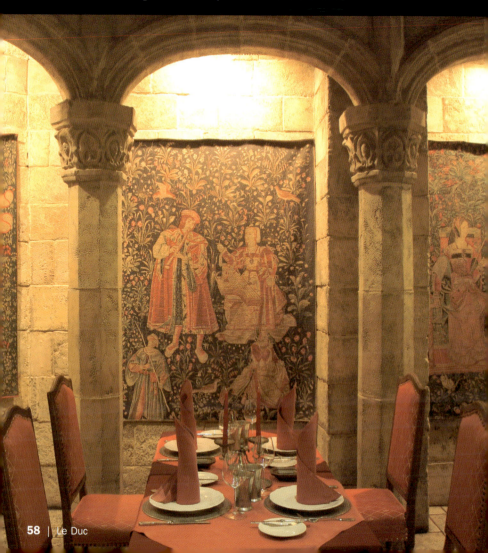

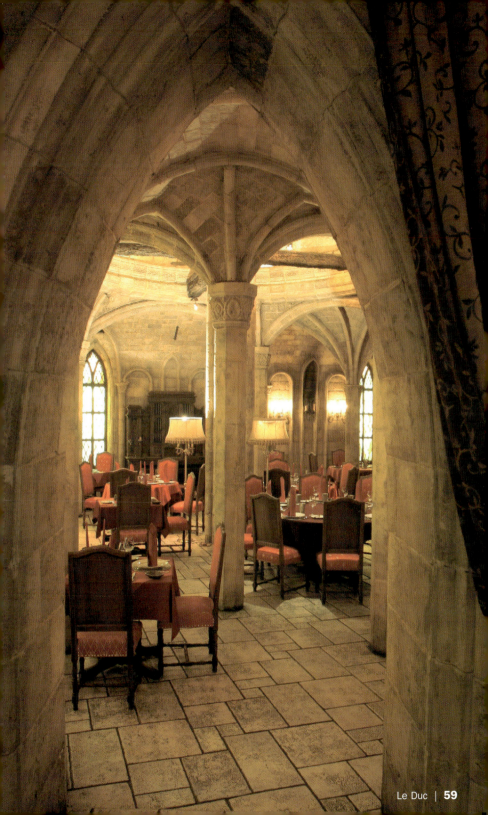

Maki Café

Design: Andrey Dmitriev | Chef: Alexander Kurenkov

3, Glinishchevsky Lane | Moscow 103306 | Tverskoe
Phone: +7 495 692 9731
Metro: Pushkinskaya, Chekhovskaya, Tverskaya
Opening hours: Sun–Thu noon to midnight, Fri–Sat noon to 5 am
Average price: $20
Cuisine: Mixed Russian, Japanese, Italian
Special features: Chill-out bar open from 7 pm onwards with DJ Fridays and Saturdays

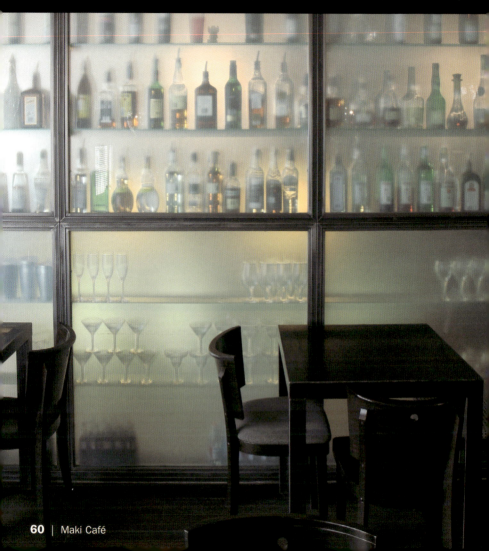

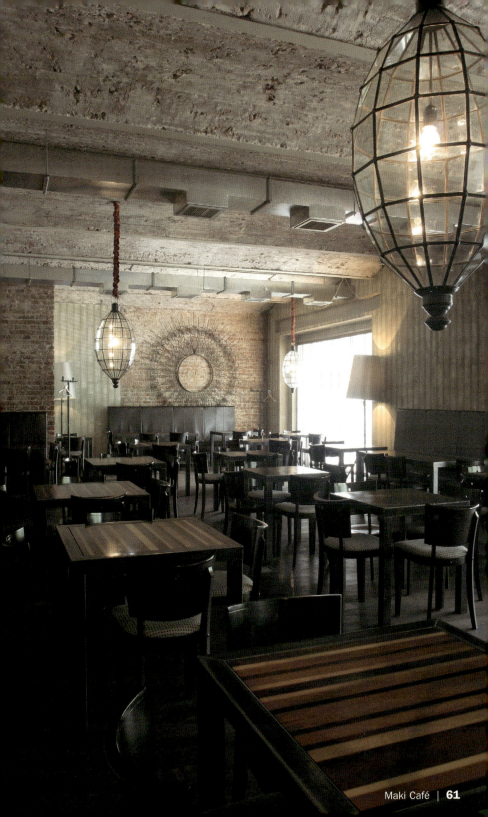

Metropol

Design: Anno 1901 | **Chef:** Mishakov Alexandr
Owner: Hotel InterContinental

1/4 Teatralny Square | Moscow 109012 | Tverskoe
Phone: +7 495 627 6061
www.metropol-moscow.ru
Metro: Teatralnaya, Lubyanka
Opening hours: Every day breakfast 7 am to 10:30 am, lunch Sat–Sun noon to 4 pm, dinner 6 pm to midnight
Average price: $30
Cuisine: Russian, European
Special features: Unique stained-glass roof, originally opened in 1903

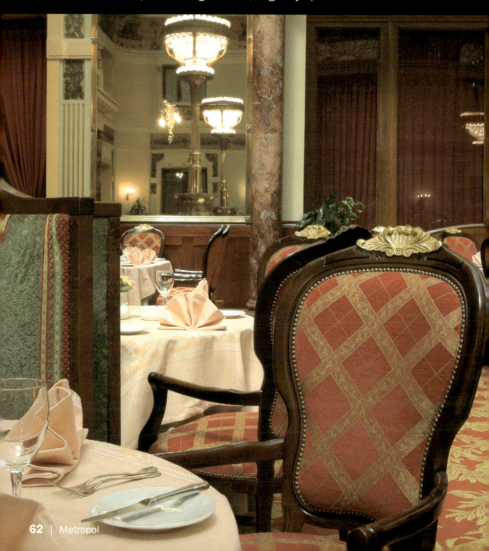

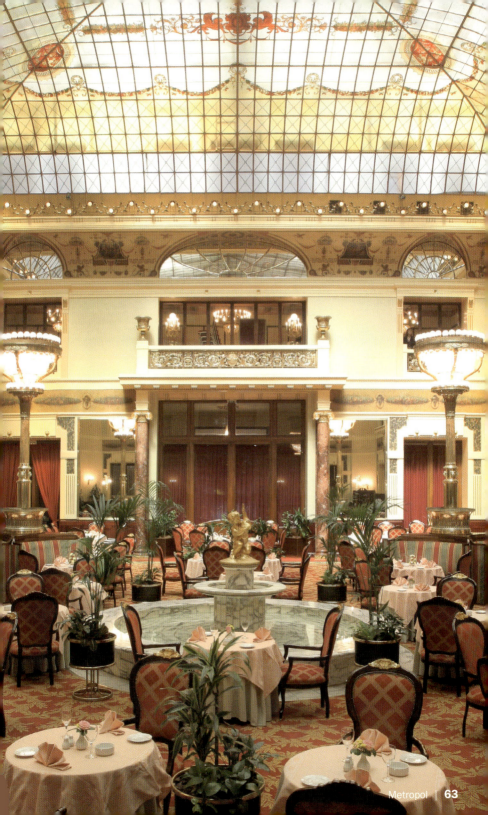

Mon Café

Design: Angela Ivanova | Chef: Vera Khromova

4, 1st Tverskaya-Yamskaya Street | Moscow 125047 | Tverskoe
Phone: +7 495 250 8800
www.moncafe.name
Metro: Mayakovskaya
Opening hours: Every day 24 hours
Average price: $50
Cuisine: French pastry, fusion
Special features: Unique interior, reminiscent of cafés on Champs-Élysées

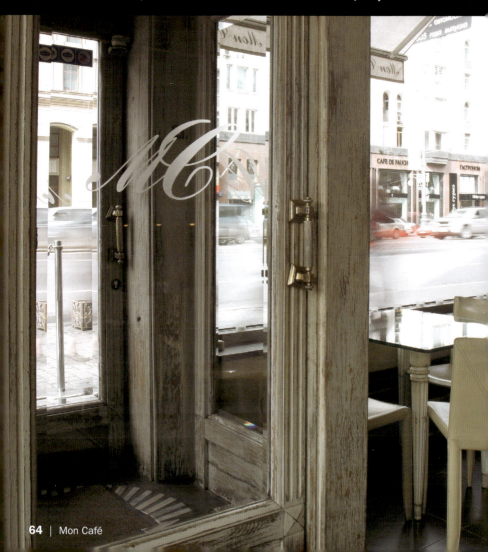

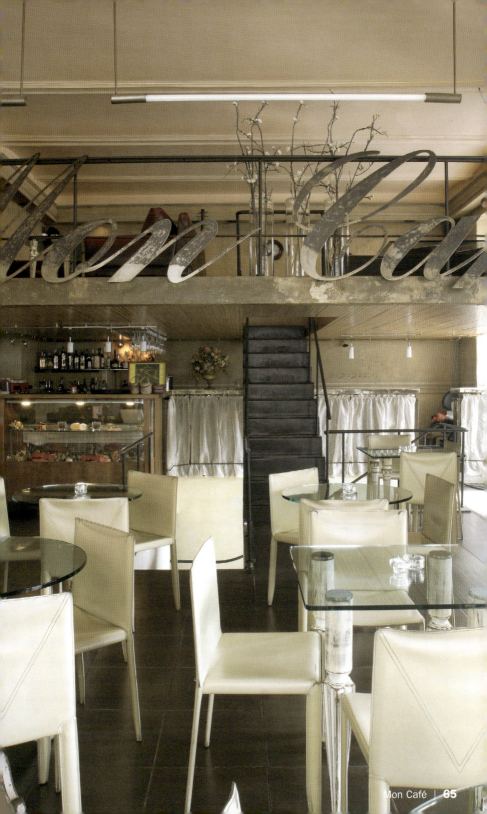

Cream Cake Mon Café

Torte Mon Café
Gâteau Mon Café
Tarta Mon Café
Torta Mon Café

5 ¼ oz flour
3 ½ oz butter
1 ⅓ oz sugar, 1 egg yolk
Quickly work all ingredients into a soft dough and chill for 2 hours. Flatten and bake in a baking dish with a diameter of 7 inches at 320 °F for 15 minutes. Chill.
8 ¾ oz raspberries
50 ml water, 3 tbsp sugar
4 leaves gelatin, soaked
Bring the raspberries with the water and sugar to a boil, blend and dissolve the gelatin in it. Let cool down a bit and spread on the short pastry. Chill.
2 eggs
1 ¾ oz sugar
3 oz almond powder
2 oz butter
2 oz pistachio paste
Beat the eggs with the sugar until frothy, then add the almond powder, melted butter and the paste and bake in a baking dish with a diameter of 7 inches at 330 °F for approx. 25 minutes. Chill, remove from the baking dish and place on top of the jelly.
3 eggs, 8 ¾ oz mascarpone (Italian cream cheese)
1 tbsp pistachio paste
5 leaves gelatin, soaked
3 tbsp sugar
150 ml cream, whipped
Cocoa powder
Mix egg yolks with mascarpone and the paste, dissolve the gelatin in little water and stir in quickly. Beat the egg whites with the sugar until stiff and fold under the mascarpone cream with the whipped cream. Fill into a pastry bag with a large opening and squirt on top of the sponge cake. Chill for at least 2 hours and dust with cocoa powder right before serving.

150 g Mehl
100 g Butter
40 g Zucker, 1 Eigelb
Alle Zutaten rasch zu einem Mürbeteig verkneten und 2 Stunden kaltstellen. Ausrollen und in einer Backform mit 18 cm Durchmesser bei 160 °C 15 Minuten backen. Abkühlen lassen.
250 g Himbeeren
50 ml Wasser, 3 EL Zucker
4 Blatt Gelatine, eingeweicht
Die Himbeeren mit dem Wasser und dem Zucker aufkochen, mixen und die Gelatine darin auflösen. Etwas abkühlen lassen und auf dem Mürbeteigboden verteilen. Kaltstellen.
2 Eier
50 g Zucker
90 g Mandelpulver
60 g Butter
60 g Pistazienpaste
Die Eier mit dem Zucker schaumig schlagen, dann das Mandelpulver, die zerlassenen Butter und die Paste unterrühren und in einer Backform mit 18 cm Durchmesser bei 165 °C ca. 25 Minuten backen. Abkühlen lassen, aus der Form lösen und auf das Gelee setzen.
3 Eier, 250 g Mascarpone
1 EL Pistazienpaste
5 Blatt Gelatine, eingeweicht
3 EL Zucker
150 ml Sahne, steif geschlagen
Kakaopulver
Die Eigelbe mit dem Mascarpone und der Paste verrühren, die Gelatine in etwas Wasser auflösen und zügig unterrühren. Die Eiweiße mit dem Zucker steif schlagen und mit der Sahne unter die Mascarpone-Creme heben. In einen Spritzbeutel mit großer Tülle füllen und auf den Pistazienbisquit spritzen. Mindestens 2 Stunden kaltstellen und kurz vor dem Servieren mit Kakao bestäuben.

150 g de farine
100 g de beurre
40 g de sucre, 1 jaune d'œuf
Malaxer tous les ingrédients pour obtenir une pâte brisée et laisser reposer 2 heures. Etaler et faire cuire 15 minutes dans un moule de 18 cm de diamètre à 160 °C. Laisser refroidir.
250 g de framboises
50 ml d'eau, 3 c. à soupe de sucre
4 feuilles de gélatine détrempées
Bouillir les framboises avec l'eau et le sucre, mixer et y dissoudre la gélatine. Laisser refroidir un peu et répartir sur le fond de pâte brisée. Mettre au frais.
2 œufs
50 g de sucre
90 g de poudre d'amandes
60 g de beurre
60 g de pâte de pistaches
Battre les œufs avec le sucre jusqu'à obtention d'un mélange mousseux, incorporer la poudre d'amandes, le beurre fondu et la pâte de pistaches. Cuire env. 25 minutes dans un moule de 18 cm de diamètre à 165 °C. Laisser refroidir, démouler et déposer sur la gelée.
3 œufs, 250 g de mascarpone
1 c. à soupe de pâte de pistaches
5 feuilles de gélatine détrempées
3 c. à soupe de sucre
150 ml crème montée en chantilly
Poudre de cacao
Mélanger les jaunes d'œuf avec le mascarpone et la pâte, dissoudre la gélatine dans un peu d'eau et incorporer rapidement. Monter les blancs en neige ferme avec le sucre et les ajouter avec la chantilly à la crème de mascarpone. Remplir une poche à large douille et déposer en cordons sur le biscuit à la pistache. Mettre au frais au moins 2 heures et saupoudrer de cacao juste avant de servir.

150 g de harina
100 g de mantequilla
40 g de azúcar, 1 yema de huevo
Hacer una pasta flora con todos los ingredientes y dejar en un lugar frío durante 2 horas. Extenderla sobre un molde de horno de 18 cm de diámetro y cocinarla al horno a 160 °C durante 15 minutos. A continuación dejarla enfriar.
250 g de frambuesas
50 ml de agua, 3 cucharadas de azúcar
4 láminas de gelatina remojada
Cocer las frambuesas con el agua y el azúcar, pasarlas por la batidora y añadir la gelatina. Dejar enfriar un poco la mezcla y extenderla sobre la base de pasta flora. Dejarla en lugar frío.
2 huevos
50 g de azúcar
90 g de almendras en polvo
60 g de mantequilla
60 g de pasta de pistachos
Batir los huevos con el azúcar a punto de nieve, añadir las almendras en polvo, la mantequilla derretida y la pasta y ponerla en un molde de horno de 18 cm de diámetro. Cocinarla en el horno a 165 °C durante 25 minutos aprox. Dejarla enfriar, sacarla del molde y colocarla sobre la gelatina.
3 huevos, 250 g de mascarpone
1 cucharada de pasta de pistachos
5 láminas de gelatina remojada
3 cucharadas de azúcar
150 ml de nata montada
Cacao en polvo
Mezclar las yemas de huevo con el mascarpone y la pasta. Derretir la gelatina en agua y verterla en la mezcla removiendo. Batir a punto de nieve las claras de huevo con el azúcar y hacer una crema añadiendo la nata y el mascarpone. Cubrir la base de pistacho con la mezcla con una manga de repostería de diámetro grande. Dejar enfriar la tarta como mínimo 2 horas y espolvorearla con el cacao antes de servirla.

150 g di farina
100 g di burro
40 g di zucchero, 1 tuorlo d'uovo
Impastare velocemente una pasta frolla con tutti gli ingredienti e metterla in frigo per 2 ore, quindi stenderla in uno stampo di 18 cm di diametro e cuocerla in forno a 160 °C per 15 minuti. Lasciarla raffreddare.
250 g di lamponi
50 ml d'acqua, 3 cucchiai di zucchero
4 fogli di gelatina ammorbiditi
Portare ad ebollizione i lamponi con l'acqua e lo zucchero, mescolare e sciogliervi la gelatina. Lasciar raffreddare un poco e stendere il composto sulla pasta frolla. Mettere in frigo.
2 uova
50 g di zucchero
90 g polvere di mandorle
60 g di burro
60 g di pasta di pistacchi
Montare le uova con lo zucchero, quindi incorporare la polvere di mandorle, il burro fuso e la pasta. Cuocere in forno a 165 °C in uno stampo di 18 cm di diametro per circa 25 minuti. Lasciar raffreddare, estrarre dallo stampo e porre sulla gelatina.
3 uova, 250 g di mascarpone
1 cucchiaio di pasta di pistacchi
5 fogli di gelatina ammorbiditi
3 cucchiai di zucchero
150 ml di panna montata
Cacao in polvere
Mescolare i tuorli d'uovo con il mascarpone e la pasta, sciogliere la gelatina in un poco d'acqua e incorporarla velocemente. Montare a neve gli albumi con lo zucchero e unirli alla crema di mascarpone insieme alla panna. Mettere il composto in una tasca di tela con bocchetta grossa e cospargerlo sul pan di spagna al pistacchio. Tenere in frigo per almeno 2 ore e spolverare di cacao al momento di servire.

Moskovsky

Design: Rogner | Chef: Mikhail Kolbasoff
Owner: Le Royal Meridien National Hotel

15/1, Mokhovaya, Hotel National | Moscow 125009 | Tverskoe
Phone: +7 495 258 7068
www.national.ru
Metro: Okhotny Ryad
Opening hours: Every day noon to 11 pm
Average price: $80
Cuisine: Russian, European
Special features: Historical restaurant, first opened in 1903, views of Kremlin

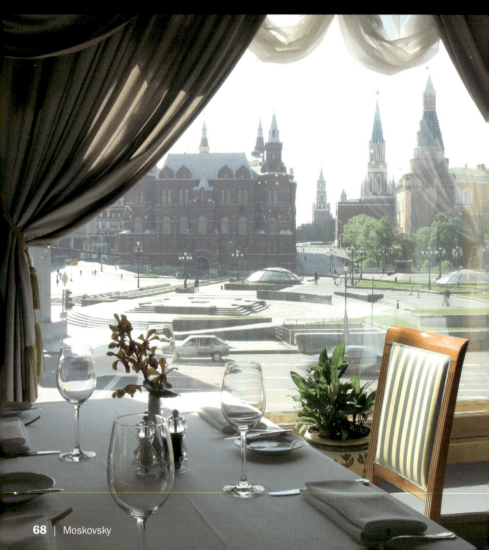

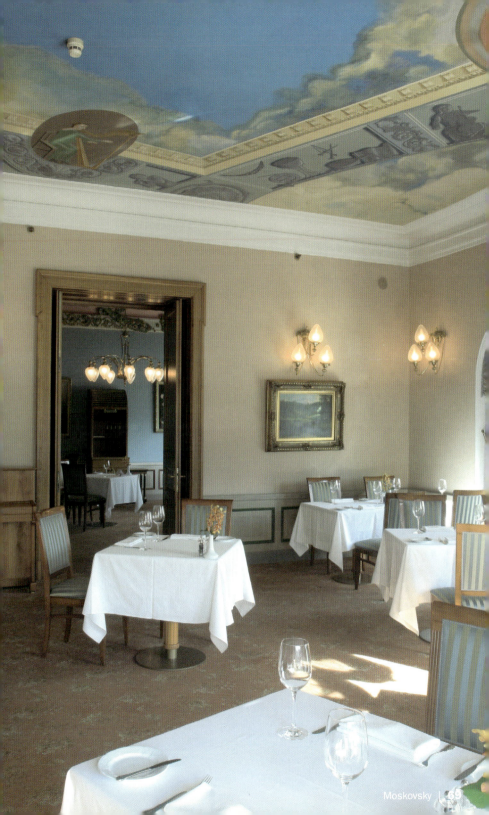

Nostalgie

Design: Mikhail Tumarkyn | Chef: Batukov Sergey
Owners: Roman Rozhnikovsky, Igor Bukharov

12a, Chistoprudny Boulevard | Moscow 101000 | Basmannoe
Phone: +7 495 625 7625, +7 495 956 9130
www.nostalgie.ru
Metro: Chistye Prudy
Opening hours: Every day noon to midnight
Average price: $100
Cuisine: French
Special features: Old wine club with expansive vintage wine collection

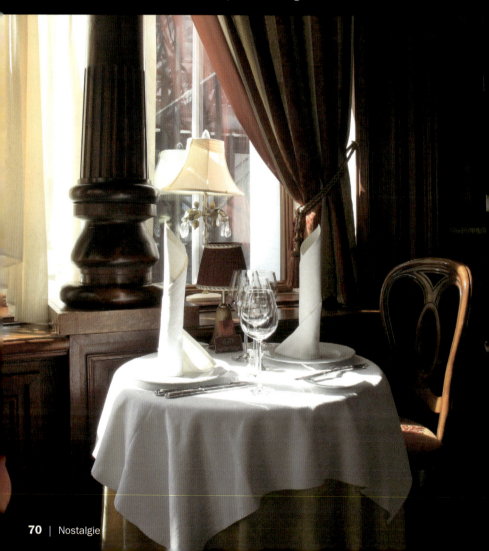

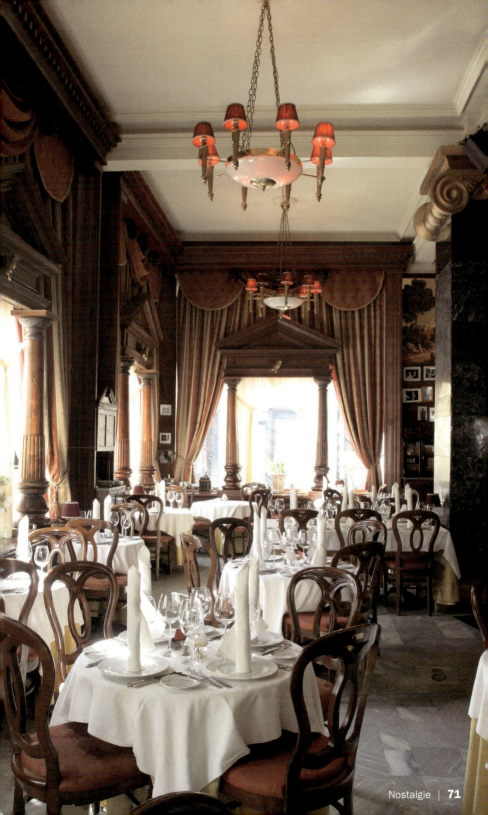

Lamb Chops with Shallot Confit

Lammkoteletts mit Schalottenconfit

Côtelettes d'agneau au confit d'échalote

Chuletas de cordero con confitado de chalotas

Costolette d'agnello con confit di scalogno

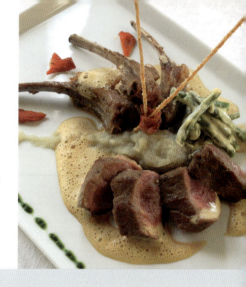

12 lamb chops in one piece
4 tbsp butter
Salt, pepper
14 oz shallots
200 ml chicken broth
7 oz green beans
100 ml cream
2 tbsp sweet mustard
150 ml beef stock
150 ml milk
1 clove of garlic
4 twigs thyme
Salt, pepper
2 dried tomatoes, cut in 6 pieces each

Remove fat and bone skin from the chops, season with salt and pepper and sear in butter for approx. 20 minutes.
Peel the shallots, chop and cook in the chicken broth until soft. Blend and season. Keep warm.
Blanch the beans. Reduce the cream with the mustard to a creamy consistency, add the beans and season.
Bring beef stock with milk, garlic and thyme to a boil, drain, season and beat until frothy.
Cut the lamb chops apart, place three chops on each plate, put beans and shallot confit in the middle, drizzle with sauce and garnish with dried tomatoes.

12 Lammkoteletts am Stück
4 EL Butter
Salz, Pfeffer
400 g Schalotten
200 ml Geflügelbrühe
200 g grüne Bohnen
100 ml Sahne
2 EL süßer Senf
150 ml Fleischbrühe
150 ml Milch
1 Knoblauchzehe
4 Zweige Thymian
Salz, Pfeffer
2 getrocknete Tomaten, gesechstelt

Die Lammkoteletts vom Fett und der Knochenhaut befreien, salzen und pfeffern und in Butter ca. 20 Minuten braten.
Die Schalotten schälen, grob würfeln und in der Geflügelbrühe weich kochen. Pürieren und würzen. Warmstellen.
Die Bohnen blanchieren. Die Sahne mit dem Senf cremig einkochen lassen, die Bohnen zufügen und abschmecken.
Die Fleischbrühe mit der Milch, dem Knoblauch und dem Thymian aufkochen, abseihen, abschmecken und aufschäumen.
Die Lammkoteletts auseinander schneiden, je drei Koteletts auf einem Teller anrichten, etwas Bohnengemüse und Schalottenconfit in die Mitte geben, mit Sauce nappieren und mit getrockneten Tomaten garnieren.

12 côtelettes d'agneau en une pièce
4 c. à soupe de beurre
Sel, poivre
400 g d'échalotes
200 ml de bouillon de volaille
200 g de haricots verts
100 ml de crème
2 c. à soupe de moutarde douce
150 ml de bouillon de viande
150 ml de lait
1 gousse d'ail
4 branches de thym
Sel, poivre
2 tomates séchées coupées en six

Débarrasser les côtelettes du gras et de la peau de l'os, saler, poivrer et cuire dans le beurre env. 20 minutes.
Eplucher les échalotes, les couper en gros dés et les faire fondre dans le bouillon de volaille. Réduire en purée et assaisonner. Garder au chaud.
Blanchir les haricots. Faire épaissir la crème avec la moutarde en réchauffant, ajouter les haricots et rectifier l'assaisonnement.
Bouillir le bouillon de viande avec le lait, l'ail et le thym, passer au chinois, rectifier l'assaisonnement et faire mousser.
Détacher les côtelettes, disposer trois côtelettes sur chaque assiette, déposer au centre un peu de haricots verts et de confit d'échalote, napper de sauce et garnir avec les tomates séchées.

12 chuletas de cordero en una pieza
4 cucharadas de mantequilla
Sal y pimienta
400 g de chalotas
200 ml de caldo de ave
200 g de judías verdes
100 ml de nata
2 cucharadas de mostaza dulce
150 ml de caldo de carne
150 ml de leche
1 diente de ajo
4 ramitas de tomillo
Sal y pimienta
2 tomates secos cortados en seis trozos

Quitar la grasa y la piel del hueso de las chuletas. Salpimentarlas y freírlas en mantequilla durante 20 minutos aprox.
Pelar las chalotas, cortarlas en cubos y cocinarlas en el caldo de ave hasta que estén al punto. Tamizarlas, sazonarlas y apartarlas en caliente.
Blanquear las judías. Cocer la nata con la mostaza hasta que tenga una consistencia cremosa, añadir las judías y sazonar.
Cocer el caldo de carne con el tomillo, el ajo y la leche, colarlo, sazonarlo y batirlo.
Cortar el trozo de carne separando las chuletillas, colocar tres chuletas en cada plato, colocar en el centro algo de verdura y el confitado de chalotas, rociar con la salsa y decorar con los tomates secos.

12 costolette d'agnello in un pezzo solo
4 cucchiai di burro
Sale, pepe
400 g di scalogni
200 ml di brodo di pollo
200 g di fagiolini
100 ml di panna
2 cucchiai di senape dolce
150 ml di brodo di carne
150 ml di latte
1 spicchio d'aglio
4 rametti di timo
Sale, pepe
2 pomodori secchi tagliati in sei

Privare le costolette d'agnello del grasso e della cartilagine, salare, pepare e rosolare nel burro per circa 20 minuti.
Sbucciare gli scalogni, tagliarli a pezzi e cuocerli nel brodo di pollo finché non saranno teneri. Passarli al passaverdura e condirli. Tenerli in caldo.
Scottare i fagiolini. Cuocere la panna e la senape fino ad ottenere un composto cremoso, aggiungere i fagiolini e regolare il condimento.
Sbollentare il brodo di carne con il latte, l'aglio e il timo, passarlo al setaccio, regolare il condimento e schiumarlo.
Staccare le costolette l'una dall'altra, mettere tre costolette su ciascun piatto, disporvi al centro alcuni fagiolini e del confit di scalogno, nappare con la salsa e guarnire con i pomodori secchi.

Oblomov

Design: Oksana Bodrova | Chef: Ilia Tyukov | Owner: Kirill Guseev

5, 1st Monetchikovsky Lane| Moscow 115054 | Zamoskvorechje
Phone: +7 495 953 6828
www.restoran-oblomov.ru
Metro: Dobryninskaya, Paveletskaya
Opening hours: Every day noon to 5 am
Average price: $60
Cuisine: Russian, French
Special features: Formerly a merchant's mansion–this defines the style of the restaurant, summer terrace, Russian tea ceremonies

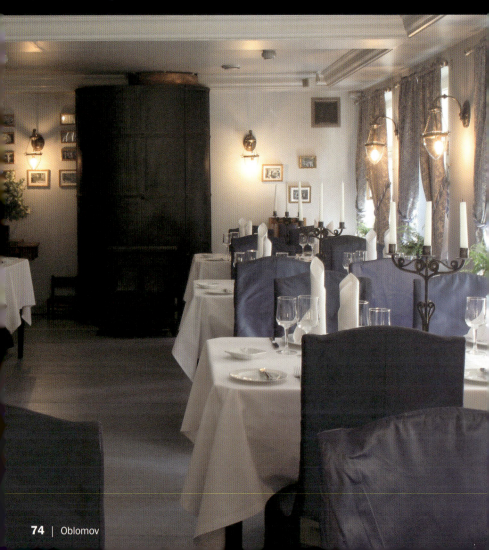

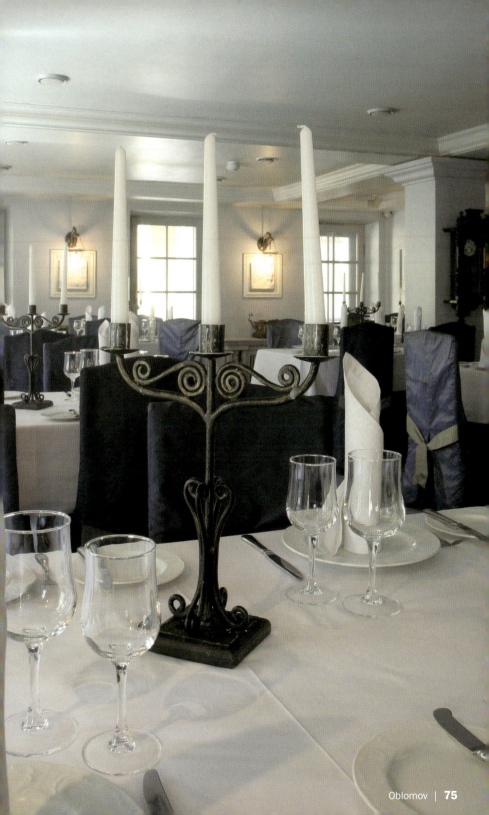

Pavillion

Design: Brano Shouz | Chef: Ilia Tyukov | Owner: Kirill Guseev

7, Bol. Patriarshy Lane | Moscow 123001 | Presnenskoe
Phone: +7 495 203 5110
www.restoran-oblomov.ru
Metro: Tverskaya, Mayakovskaya
Opening hours: Every day 10 am to 5 am
Average price: $70
Cuisine: Author's
Special features: View over pond with swans, ducks, and geese, 15 types of hookah pipes

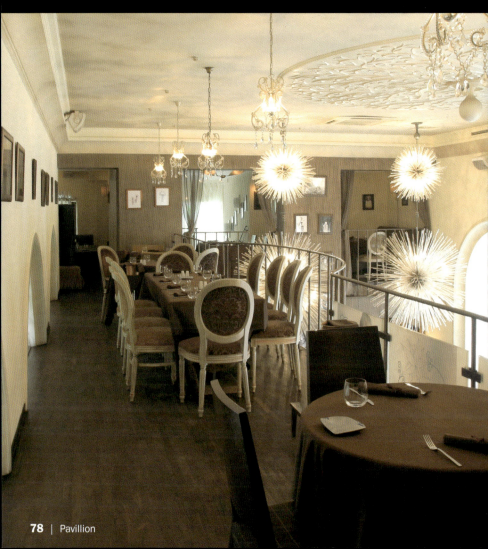

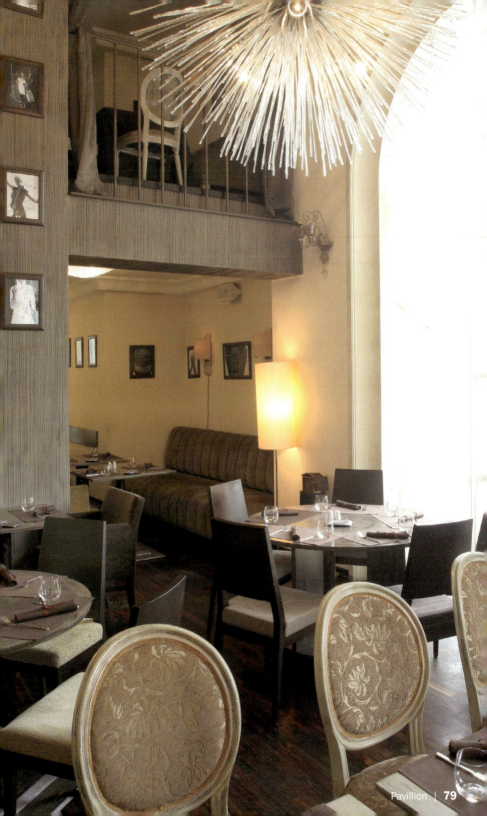

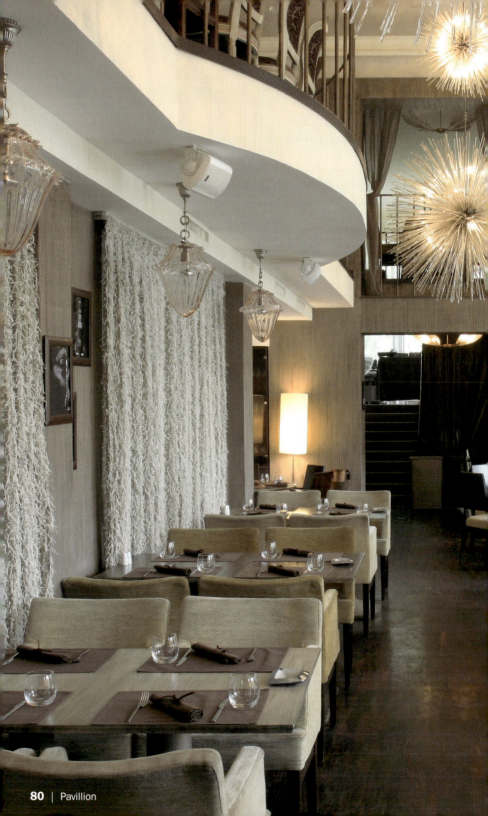

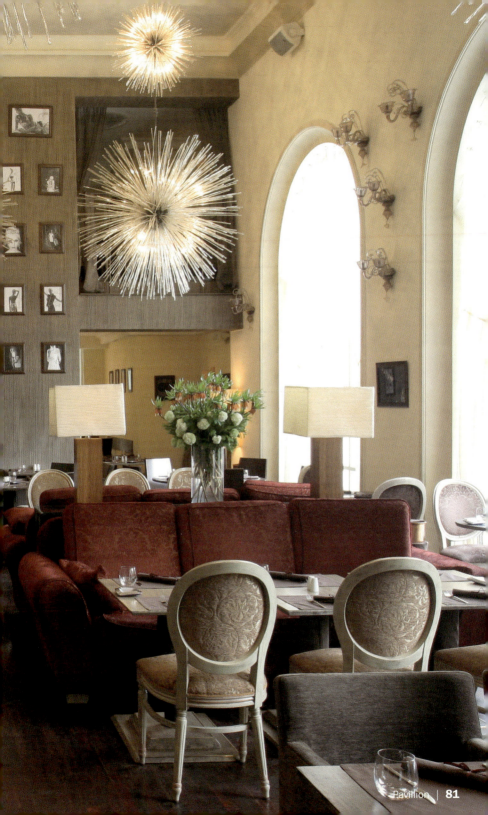

Chicken breast
with Curry Sauce and Mango Chutney

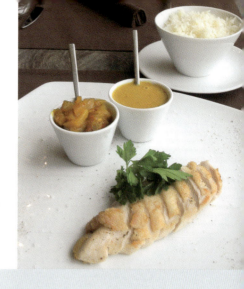

Hähnchenbrust mit Currysauce und Mangochutney

Blanc de poulet avec sauce curry et chutney à la mangue

Pechuga de pollo con salsa de curry y chutney de mango

Petti di pollo con salsa al curry e chutney di mango

4 chicken breasts, with skin
Salt, pepper
5 tbsp vegetable oil
2 mangos
1 shallot, diced
1 tsp soy sauce
1 tbsp curry
200 ml coconut milk
Salt, pepper, sugar
10 ½ oz Basmati rice
700 ml water

Bring rice with the water and 1 tsp salt to a boil and cook on small heat for approx. 20 minutes. Peel the mangos, cut in rough chunks, sauté the shallot in 1 tbsp oil, add the mango chunks, season with soy sauce, salt, pepper and sugar and bring to a boil.
Sauté the curry in 2 tbsp oil, deglaze with coconut milk and reduce to a creamy sauce. Season and pour into four small bowls. Fill the mango chutney into four small bowls as well.
Season the chicken breasts with salt and pepper, then sear for 2 minutes in 2 tbsp oil on the skin side first, then sear for another 3 minutes on the other side. Wrap in foil, let rest for 5 minutes and cut into slices.
Arrange on four plates, place the bowls on the plates and garnish with coriander leaves. Serve the rice separately.

4 Hähnchenbrüste, mit Haut
Salz, Pfeffer
5 EL Pflanzenöl
2 Mangos
1 Schalotte, gewürfelt
1 TL Sojasauce
1 EL Curry
200 ml Kokosmilch
Salz, Pfeffer, Zucker
300 g Basmati-Reis
700 ml Wasser

Den Reis mit dem Wasser und 1 TL Salz aufkochen und auf niedrigster Stufe 20 Minuten quellen lassen.
Die Mangos schälen, in grobe Stücke schneiden, die Schalotte in 1 EL Öl anschwitzen, die Mangostücke zugeben, mit Sojasauce, Salz, Pfeffer und Zucker abschmecken und einmal aufkochen.
Den Curry in 2 EL Öl anschwitzen, mit Kokosmilch ablöschen und zu einer cremigen Sauce einkochen lassen. Abschmecken und in vier Schälchen füllen. Das Mangochutney ebenfalls in vier Schälchen füllen.
Die Hähnchenbrüste salzen und pfeffern und in 2 EL Öl zuerst auf der Hautseite 2 Minuten anbraten, dann nochmals 3 Minuten auf der anderen Seite braten. In Alufolie wickeln, 5 Minuten ruhen lassen und in Scheiben schneiden.
Auf vier Teller arrangieren, die Schälchen auf die Teller stellen und mit Korianderblättern garnieren. Den Reis separat dazu servieren.

4 blancs de poulet avec la peau
Sel, poivre
5 c. à soupe d'huile végétale
2 mangues
1 échalote en dés
1 c. à café de sauce soja
1 c. à soupe de curry
200 ml de lait de coco
Sel, poivre, sucre
300 g de riz basmati
700 ml d'eau

Amener à ébullition le riz dans l'eau avec 1 c. à café de sel et cuire 20 minutes à la température la plus basse.
Peler les mangues, les couper en gros morceaux, faire revenir l'échalote dans une c. à soupe d'huile, ajouter les morceaux de mangue, assaisonner de sauce soja, sel, poivre et sucre et donner un tour de bouillon.
Faire revenir le curry dans 2 c. à soupe d'huile, mouiller avec le lait de coco et réduire jusqu'à obtention d'une sauce crémeuse. Rectifier l'assaisonnement et verser dans quatre petites jattes. Mettre également le chutney de mangue dans quatre petites jattes.
Saler et poivrer les blancs de poulet et les saisir d'abord côté peau 2 minutes dans 2 c. à soupe d'huile, puis les dorer 3 minutes de l'autre côté. Les envelopper dans une feuille d'aluminium, laisser reposer 5 minutes et couper en tranches.
Disposer sur quatre assiettes, placer les jattes sur les assiettes et garnir de feuilles de coriandre. Accompagner de riz servi séparément.

4 pechugas de pollo con piel
Sal y pimienta
5 cucharadas de aceite vegetal
2 mangos
1 chalota picada
1 cucharadita de salsa de soja
1 cucharada de curry
200 ml de leche de coco
Sal, pimienta y azúcar
300 g de arroz basmati
700 ml de agua

Cocer al arroz con el agua y 1 cucharadita de sal a fuego muy lento durante 20 minutos.
Pelar los mangos y cortarlos en trozos grandes. Sofreír la chalota en 1 cucharada de aceite y añadir los trozos de mango, sazonar con salsa de soja, sal, pimienta y azúcar y dejar que cueza.
Rehogar el curry con 2 cucharadas de aceite, cocerlo con la leche de coco y reducirlo hasta conseguir una salsa espesa. Salpimentarlo y verterlo en cuatro cuencos. Servir también el chutney de mango en cuatro cuencos.
Salpimentar las pechugas de pollo y freírlas con 2 cucharadas de aceite, primero por el lado de la piel durante 2 minutos, y después 3 minutos por la otra cara. Enrollarlas en papel de aluminio, dejarlas reposar durante 5 minutos y cortarlas en rodajas.
Distribuir las rodajas en cuatro platos, colocar en cada plato los cuencos y decorar con hojas de cilantro. Servir el arroz por separado.

4 petti di pollo con la pelle
Sale, pepe
5 cucchiai di olio vegetale
2 mango
1 scalogno tagliato a dadini
1 cucchiaino di salsa di soia
1 cucchiaio di curry
200 ml di latte di cocco
Sale, pepe, zucchero
300 g di riso Basmati
700 ml di acqua

Portare ad ebollizione il riso nell'acqua con un cucchiaino di sale e lasciarlo cuocere a fiamma bassissima per 20 minuti.
Sbucciare i mango, tagliarli a grossi pezzi, rosolare lo scalogno in 1 cucchiaio di olio, unire i pezzi di mango, condire con la salsa di soia, il sale, il pepe e lo zucchero e portare di nuovo ad ebollizione.
Rosolare il curry in 2 cucchiai di olio, bagnare con il latte di cocco e far restringere fino ad ottenere una salsa cremosa. Regolare il condimento e versare sia la salsa sia il chutney di mango in quattro ciotole.
Salare e pepare i petti di pollo e rosolarli in 2 cucchiai di olio per 2 minuti prima dalla parte della pelle, quindi altri 3 minuti dall'altra parte. Avvolgerli in carta d'alluminio, lasciarli riposare per 5 minuti e tagliarli a fette.
Disporli su quattro piatti, poggiare sui piatti anche le ciotoline, e guarnire con foglie di coriandolo. Servire il riso a parte.

Peperoni

Design: Albina Nazimova | Chef: Andrea Galli
Owner: Arkady Novikov

17/1, Petrovka Street | Moscow 107031 | Tverskoe
Phone: +7 495 980 7350
www.novikovgroup.ru
Metro: Teatralnaya, Chekhovskaya
Opening hours: Every day noon to last guest
Average price: $60
Cuisine: Italian
Special features: Incorporates small shop with Italian specialties and fresh products

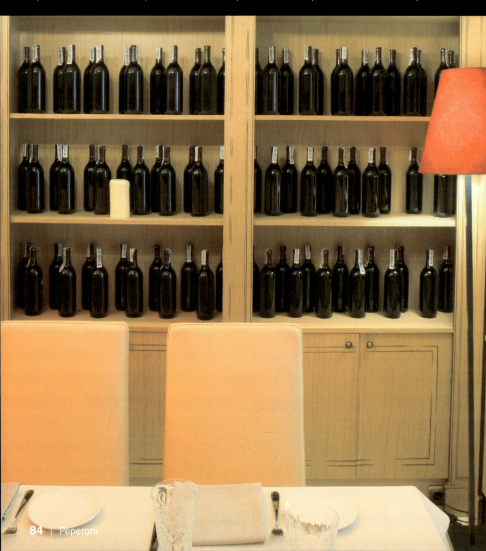

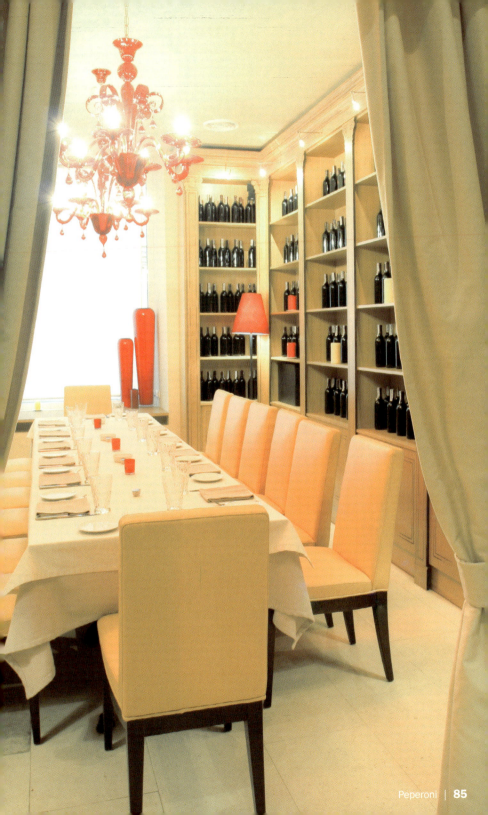

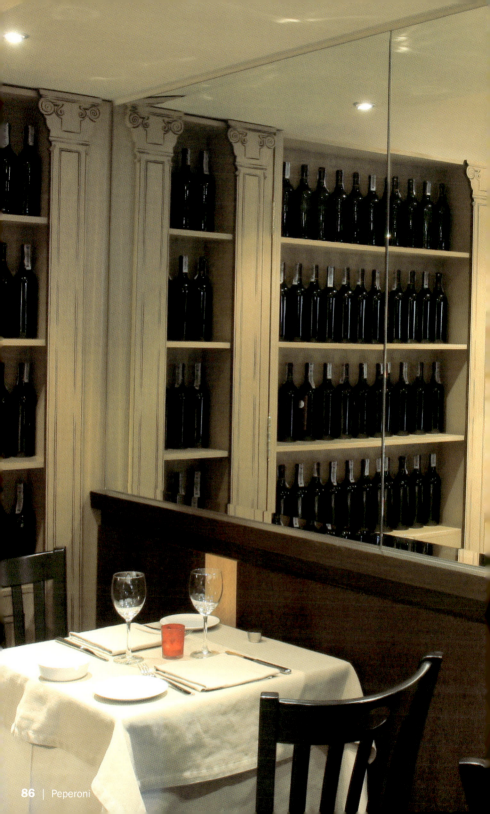

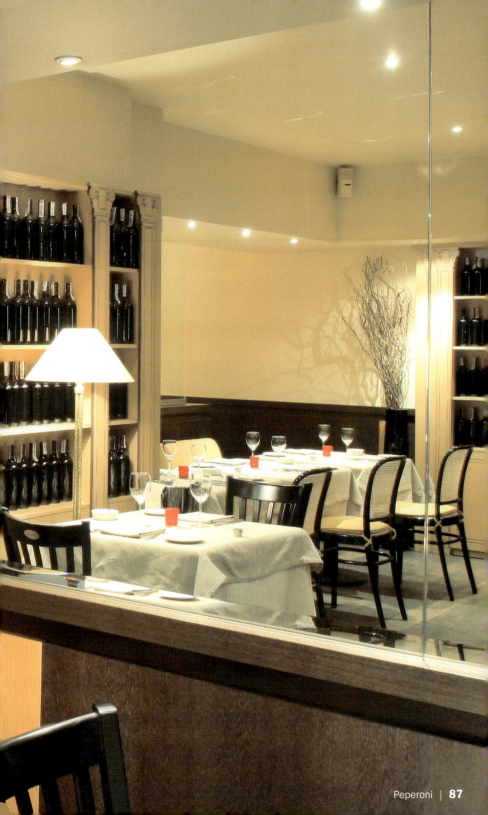

Propaganda

Design: Peter Pasternak | Chef: Nina Yakovlevna
Owner: Alexander Cyril

7, Bolshoi Zlatoustinsky Lane | Moscow 101000 | Kitay-Gorod
Phone: +7 495 624 5732
www.propagandamoscow.com
Metro: Kitay-Gorod
Opening hours: Every day noon to 6 am
Average price: $20
Cuisine: Fusion
Special features: Restaurant during the day, club at night

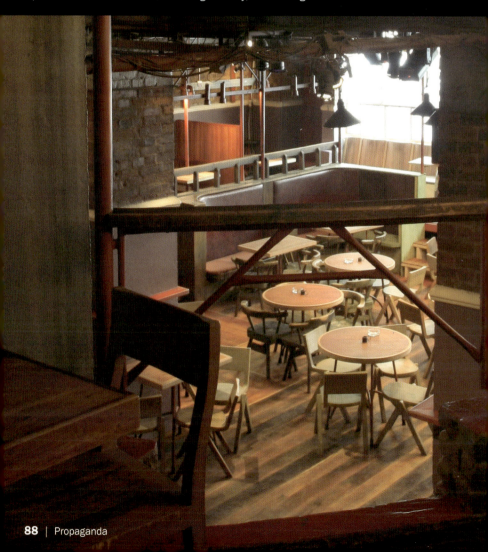

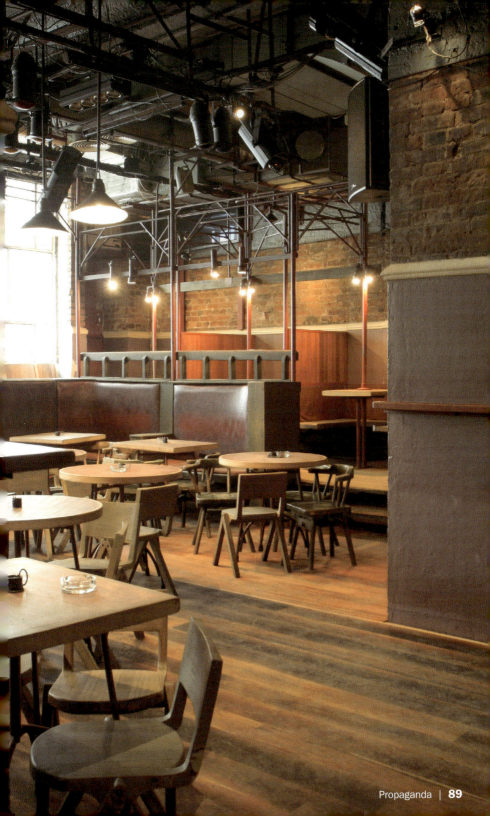

Spinach Salad with Fried Bacon

Spinatsalat mit gebratenem Speck
Salade d'épinard au lard sauté
Ensalada de espinacas con panceta frita
Insalata di spinaci con speck arrosto

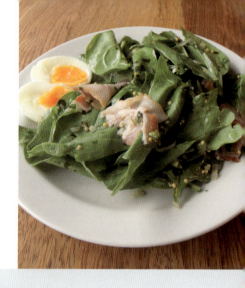

14 oz young spinach, washed and dried off
8 slices bacon
2 tbsp vegetable oil
4 eggs

3 tbsp vinegar
1 tsp whole mustard seeds
2 tbsp chopped coriander
2 tbsp chopped parsley
2 tbsp diced onion
Salt, pepper
4 tbsp olive oil

Boil the eggs for 6 minutes, chill and peel. Keep warm.
Sear the bacon in oil until crispy, dry off on kitchen paper and break up into bits. Keep warm.
Combine all ingredients for the vinaigrette and season if necessary.
Marinade the spinach with the vinaigrette, divide among four plates and sprinkle with the bacon bits. Cut the eggs in half and place two halves beside the salad.

400 g Spinatsalat, gewaschen und geschleudert
8 Scheiben Speck
2 EL Pflanzenöl
4 Eier

3 EL Essig
1 EL ganze Senfkörner
2 EL gehackter Koriander
2 EL gehackte Petersilie
2 EL Zwiebelwürfel
Salz, Pfeffer
4 EL Olivenöl

Die Eier 6 Minuten kochen, abschrecken und pellen. Warmstellen.
Den Speck in Öl knusprig braten, auf Küchenkrepp abtropfen lassen und in Stücke brechen. Warmstellen.
Alle Zutaten für die Vinaigrette gründlich mischen und evtl. noch einmal abschmecken.
Den Spinatsalat mit der Vinaigrette marinieren, auf vier Tellern verteilen und mit Speckstücken bestreuen. Die Eier halbieren und jeweils zwei Hälften neben den Salat setzen.

400 g de salade d'épinard lavé et égoutté
8 tranches de lard
2 c. à soupe d'huile végétale
4 œufs

3 c. à soupe de vinaigre
1 c. à soupe de graines de moutarde entières
2 c. à soupe de coriandre hachée
2 c. à soupe de persil haché
2 c. à soupe d'oignons en dés
Sel, poivre
4 c. à soupe d'huile d'olive

Faire cuire les œufs durs 6 minutes, les passer sous l'eau froide et les écaler. Garder au chaud.
Faire croustiller le lard dans de l'huile, absorber l'excès de gras avec du sopalin, rompre le lard en morceaux. Garder au chaud.
Bien mélanger tous les ingrédients pour la vinaigrette et rectifier l'assaisonnement si nécessaire.
Assaisonner la salade d'épinard avec la vinaigrette, répartir sur quatre assiettes et parsemer de morceaux de lard. Couper les œufs en deux et placer deux moitiés à côté de la salade.

400 g de espinacas de ensalada lavadas y escurridas
8 lonchas de panceta
2 cucharadas de aceite vegetal
4 huevos

3 cucharadas de vinagre
1 cucharada de granos de mostaza
2 cucharadas de cilantro picado
2 cucharadas de perejil picado
2 cucharadas de cebolla picada
Sal y pimienta
4 cucharadas de aceite de oliva

Cocer los huevos durante 6 minutos, escaldarlos y pelarlos. Reservarlos calientes.
Dorar la panceta en aceite hasta que esté crujiente, escurrir en papel absorbente y romperla en trozos. Reservar en caliente.
Mezclar todos los ingredientes para la vinagreta y salpimentar si es necesario.
Marinar las espinacas con la vinagreta, distribuirlas en cuatro platos y espolvorear en ella los trozos de panceta. Cortar los huevos a la mitad y colocar las dos mitades en cada plato junto a la ensalada.

400 g di insalata di spinaci, lavata e centrifugata
8 fette di speck
2 cucchiai di olio vegetale
4 uova

3 cucchiai di aceto
1 cucchiaio di grani di senape interi
2 cucchiai di coriandolo tritato
2 cucchiai di prezzemolo tritato
2 cucchiai di dadini di cipolla
Sale, pepe
4 cucchiai di olio di oliva

Rassodare le uova per 6 minuti, immergerle in acqua fredda e sgusciarle. Tenerle al caldo.
Rosolare lo speck nell'olio finché non sarà diventato croccante, sgocciolarlo su carta assorbente da cucina e spezzettarlo. Tenerlo al caldo.
Mescolare bene tutti gli ingredienti per la vinaigrette ed, eventualmente, regolare il condimento.
Marinare l'insalata di spinaci nella vinaigrette, disporla in quattro piatti e ripartirvi sopra i pezzi di speck. Dimezzare le uova e porne due metà in ciascun piatto accanto all'insalata.

Shatush

Design: Konstantin Chernyavsky | Chef: Alfie Seah

17, Gogolevsky Boulevard | Moscow 119019 | Khamovniki
Phone: +7 495 201 4071
www.shatush.ru
Metro: Kropotkinskaya
Opening hours: Every day 24 hours
Average price: $50
Cuisine: Asian fusion
Special features: Luxurious summer terrace, performances on the bar counter: go-go-girls, barmen fire show, saxophonist, artists

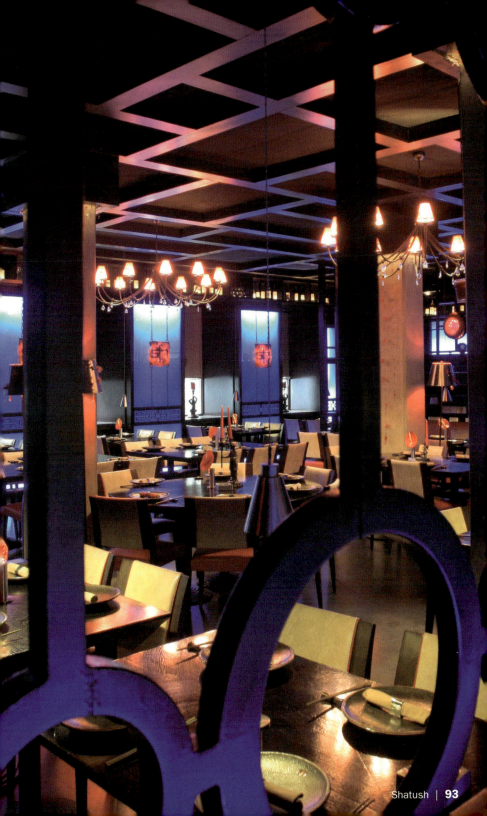

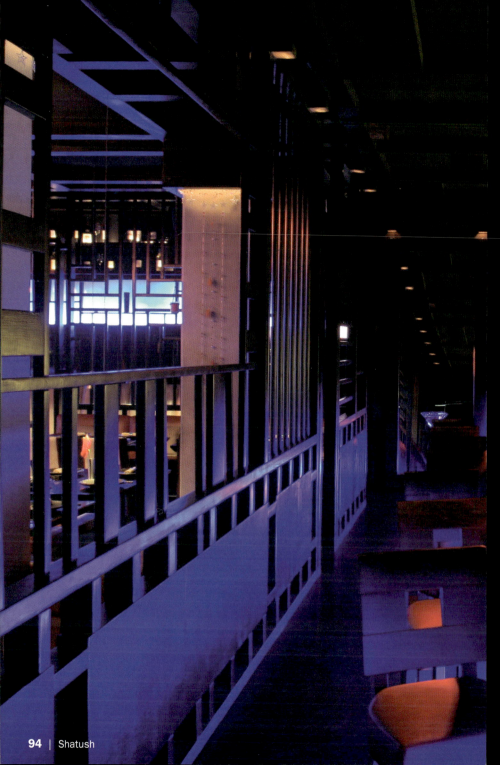

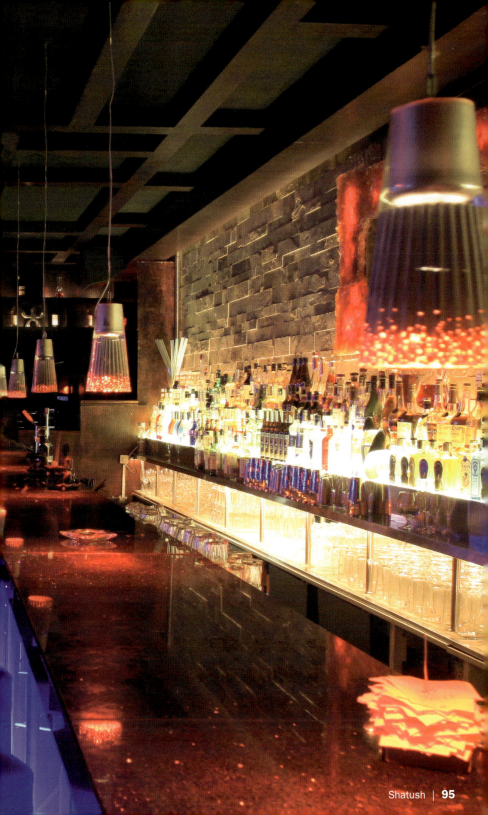

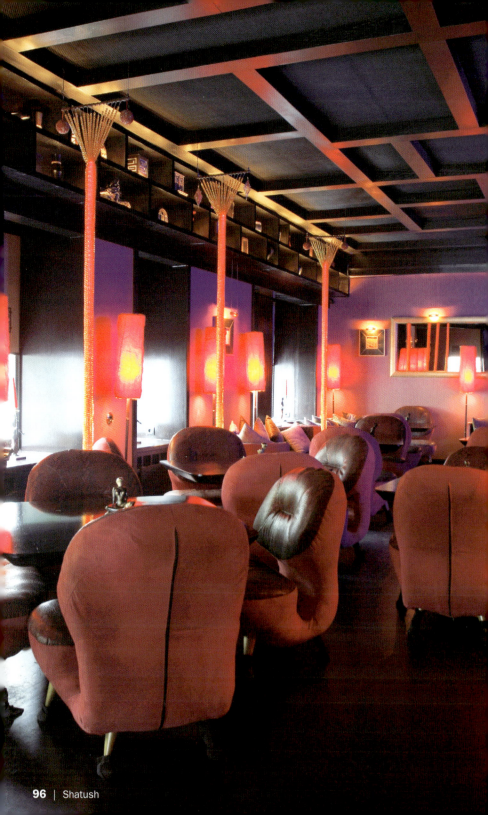

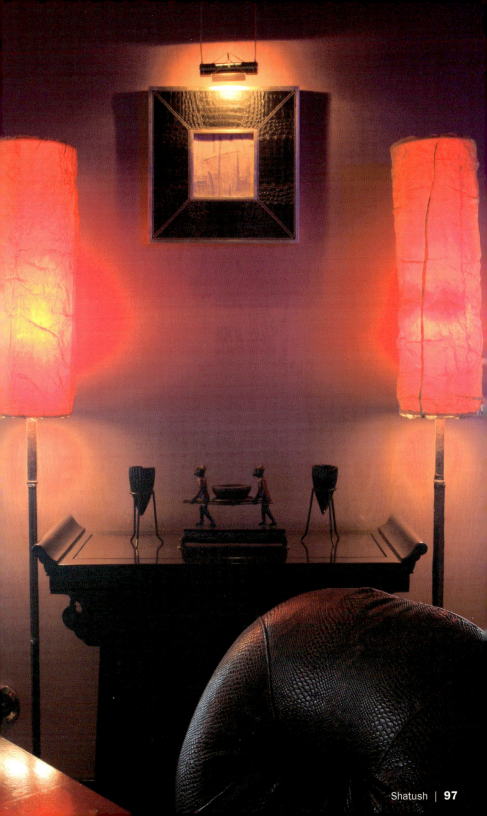

Shinok

Design: Andrey Dellos, Alexandr Popov | Chef: Oleg Porotikov
Owner: Andrey Dellos

2, 1905 Goda Street | Moscow 123100 | Presnenkoe
Phone: +7 495 255 0888
www.shinok.ru
Metro: Ulitca 1905 Goda
Opening hours: Every day, 24 hours
Average price: $60
Cuisine: Ukrainian
Special features: Small farm with animals in the center of restaurant

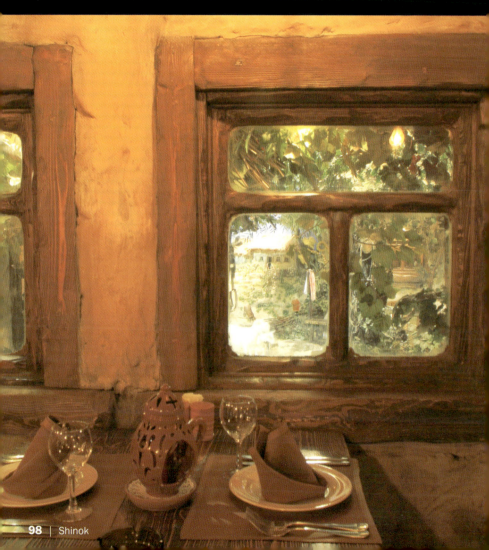

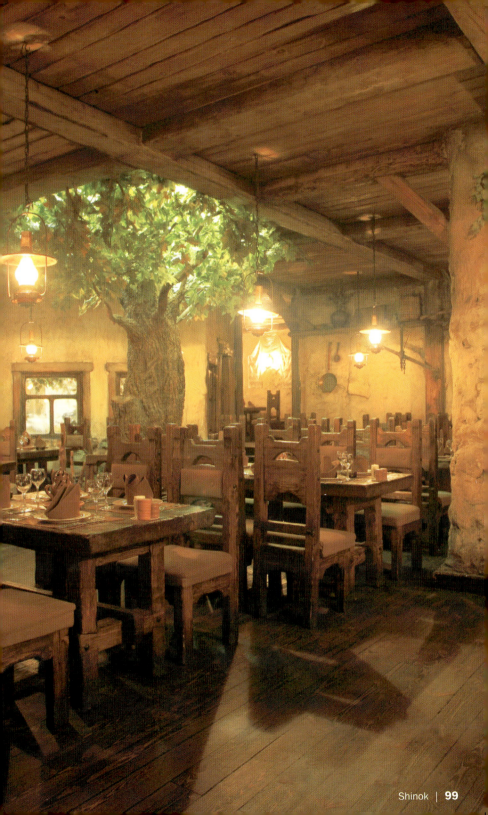

Suzy Wong

Design: Evgeny Mitta, Giya Abramishvili | Chef: Andrei Gribenko

11, Timura Frunze Street, Building 34 | Moscow 119021 | Khamovniki
Phone: +7 495 245 4849
www.suzywongbar.ru
Metro: Park Kultury
Opening hours: Every day noon to last guest
Average price: $30
Cuisine: Chinese
Special features: Live gigs, DJs, changing art exhibitions

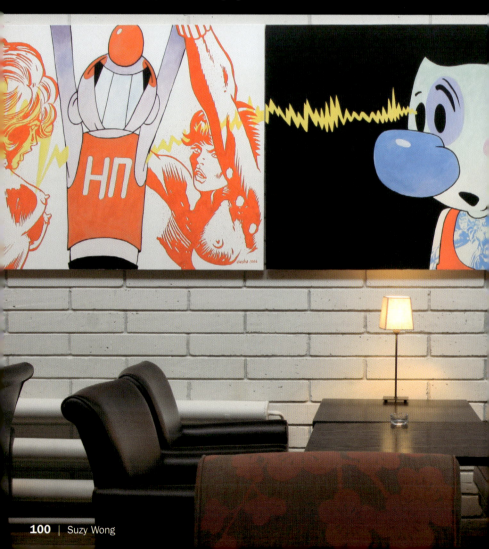

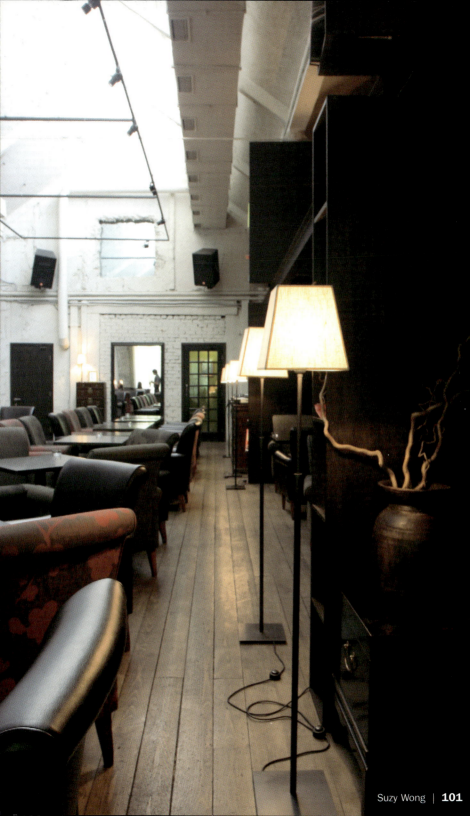

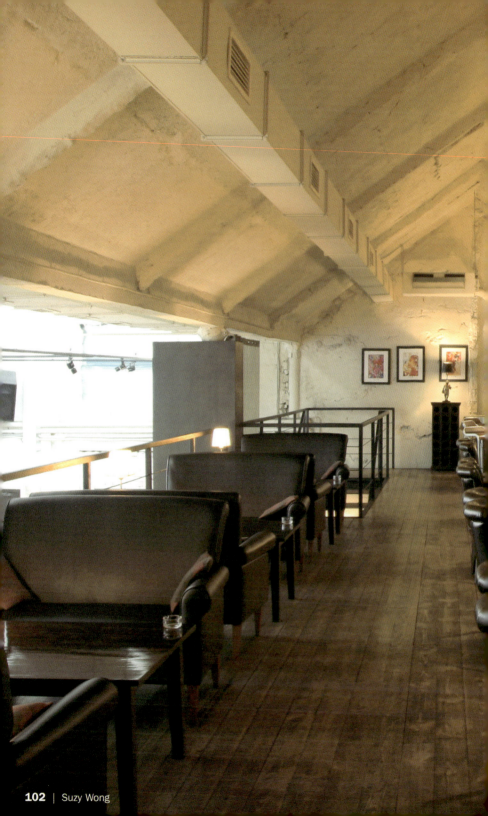

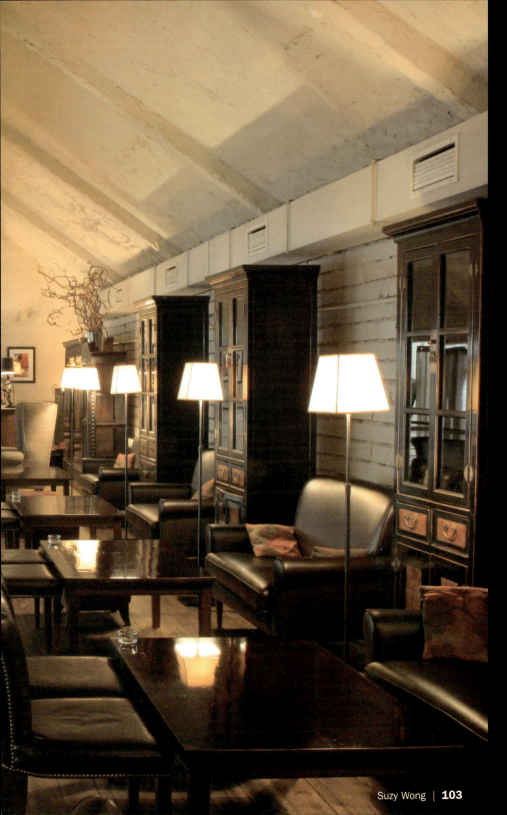

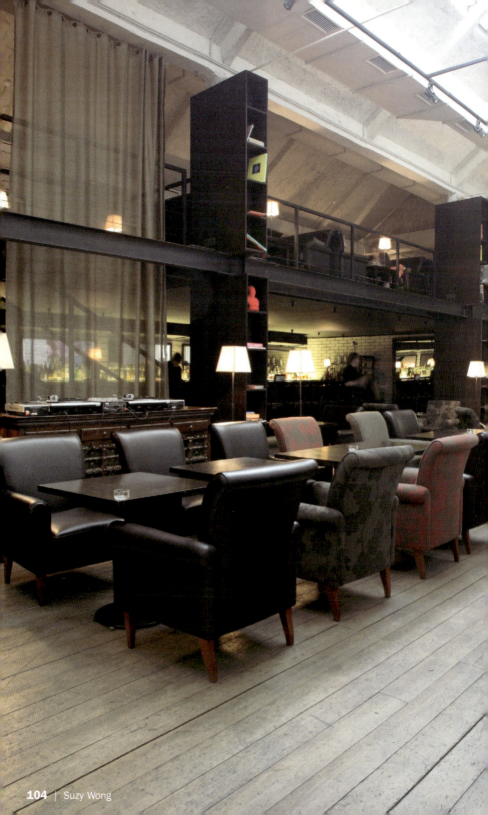

Piccolo

30 ml vodka
30 ml pomegranate juice
5 ml ginger syrup
10 ml lime juice
5 ml sugar syrup
15 ml honey
1 tbsp pomegranate seeds

1 tall frozen glass
1 straw

Fill the honey and pomegranate seeds into the glass, combine the other ingredients in a shaker, shake well and carefully pour into the glass along the edge of the glass. Serve immediately.

30 ml Wodka
30 ml Granatapfelsaft
5 ml Ingwersirup
10 ml Limettensaft
5 ml Zuckersirup
15 ml Honig
1 EL Granatapfelkerne

1 hohes gefrorenes Glas
1 Strohhalm

Den Honig und die Granatapfelkerne in das Glas geben, die übrigen Zutaten kräftig mischen und vorsichtig am Glasrand entlang in das Glas laufen lassen. Sofort servieren.

30 ml de vodka
30 ml de jus de grenade
5 ml de sirop de gingembre
10 ml de jus de limette
5 ml de sirop de sucre
15 ml de miel
1 c. à soupe de pépins de grenade

1 verre haut givré
1 paille

Mettre le miel et les pépins de grenade dans le verre, mélanger vigoureusement les autres ingrédients et les faire couler lentement, du bord, le long du verre. Servir de suite.

30 ml de vodka
30 ml de zumo de granada
5 ml de sirope de jengibre
10 ml de zumo de lima
5 ml de almíbar
15 ml de miel
1 cucharada de granos de granada

1 copa alta congelada
1 pajita

Verter en la copa la miel y los granos de granada, mezclar bien el resto de los ingredientes y verter despacio en la copa por el borde. Servir al instante.

30 ml di vodka
30 ml di succo di melagrane
5 ml di sciroppo di zenzero
10 ml di succo di limetta
5 ml di sciroppo di zucchero
15 ml di miele
1 cucchiaio di semi di melagrana

1 bicchiere alto precedentemente messo nel congelatore
1 cannuccia

Mettere nel bicchiere il miele e i semi di melagrana, mescolare bene gli altri ingredienti e aggiungerli con cautela facendoli scorrere sul bordo del bicchiere. Servire subito.

Uley

Chef: Michel Loga | Owner: Oleg Bardeev

7, Gasheka Street | Moscow 123056 | Presnenskoe
Phone: +7 495 797 4333, +7 495 797 3090
www.uley.ru
Metro: Belorusskaya, Mayakovskaya
Opening hours: Mon–Fri noon to midnight, Sat–Sun 2 pm to 2 am
Average price: $65
Cuisine: Fusion, Oriental, Author's
Special features: Catering

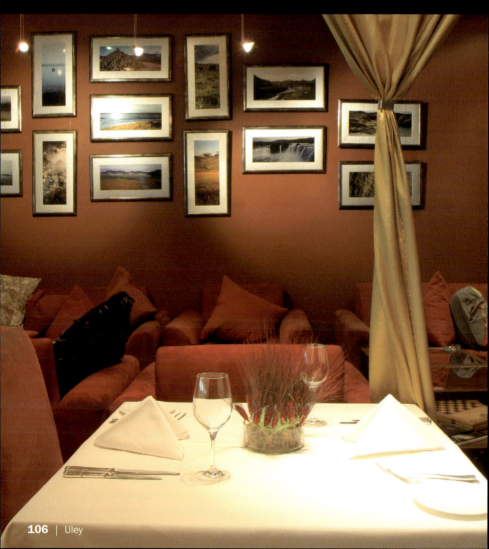

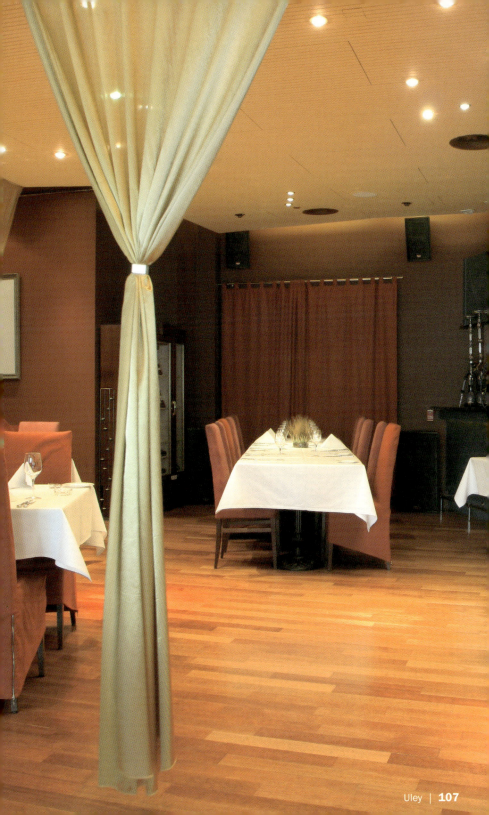

Tomato-Sorrel-Salad

Tomaten-Sauerampfer-Salat
Salade de tomate et d'oseille
Ensalada de tomates y acedera
Insalata di pomodori e romice acetosa

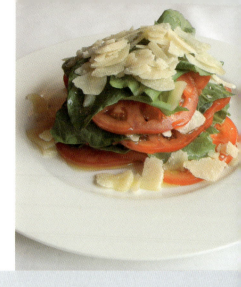

6 beef tomatoes
5 ¼ oz sorrel
7 oz parmesan
Salt, pepper
Olive oil

Cut the beef tomatoes in thin slices. Wash and dry off the sorrel. Cut the parmesan in thin shavings.
Layer tomatoes, sorrel and parmesan shavings alternately to four stacks, finish with sorrel and parmesan. Season the tomato slices with salt and pepper. Drizzle each stack with olive oil.

6 Fleischtomaten
150 g Sauerampfer
200 g Parmesan
Salz, Pfeffer
Olivenöl

Die Fleischtomaten in dünne Scheiben schneiden. Den Sauerampfer waschen und trocken tupfen. Den Parmesan in dünne Scheiben hobeln.
Abwechselnd Tomaten, Sauerampfer und Parmesanhobel zu vier Stapeln aufschichten, mit Sauerampfer und Parmesan abschließen. Die Tomatenscheiben salzen und pfeffern. Jeden Stapel mit Olivenöl beträufeln.

6 tomates charnues
150 g d'oseille
200 g de parmesan
Sel, poivre
Huile d'olive

Couper les tomates en fines tranches. Laver l'oseille et en essuyer les feuilles. Faire de fins copeaux de parmesan.
Confectionner quatre piles en alternant des couches de tomates, d'oseille et de copeaux de parmesan. Terminer par de l'oseille et du parmesan. Saler et poivrer les tranches de tomates. Arroser chaque pile de quelques gouttes d'huile d'olive.

6 tomates carnosos
150 g de acedera
200 g de parmesano
Sal y pimienta
Aceite de oliva

Cortar los tomates en rodajas finas. Lavar la acedera y cortarla en seco. Laminar fino el parmesano.
Disponer cuatro torres intercalando una rodaja de tomate, acedera y una lámina de parmesano. Salpimentar las rodajas de tomate. Rociar cada torre con aceite de oliva.

6 pomodori da insalata
150 g di romice acetosa
200 g di parmigiano
Sale, pepe
Olio di oliva

Tagliare i pomodori a fette sottili. Lavare e asciugare la romice acetosa. Tagliare a scaglie il parmigiano.
Disporre in quattro strati i pomodori, la romice acetosa e le scaglie di parmigiano, terminando con la romice acetosa e il parmigiano. Salare e pepare le fette di pomodoro. Pillottare ogni porzione con olio di oliva.

Vanil

Design: Yury Andreev | Chef: Kamel Benamer
Owners: Fedor Bondarchuk, Stepan Mikhalkov, Arkady Novikov

1, Ostozhenka Street | Moscow 119034 | Khamovniki
Phone: +7 495 202 3341
www.eatout.ru, www.novikovgroup.ru
Metro: Kropotkinskaya
Opening hours: Every day noon to midnight
Average price: $70
Cuisine: French, Japanese, Contemporary European
Special features: Outdoor seating, views of temple of Christ Saviour

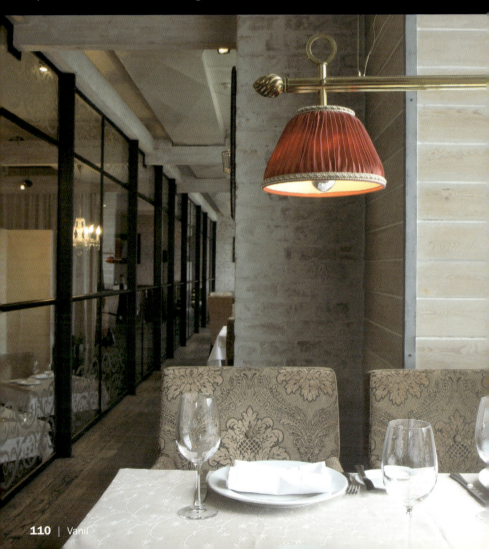

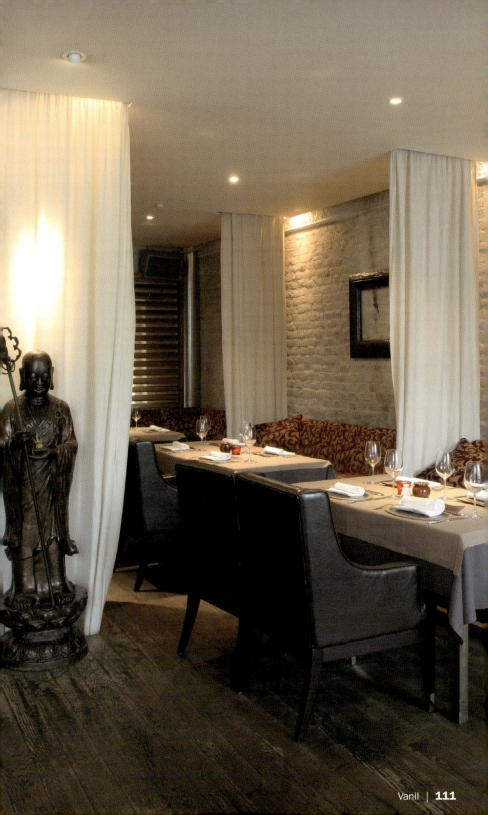

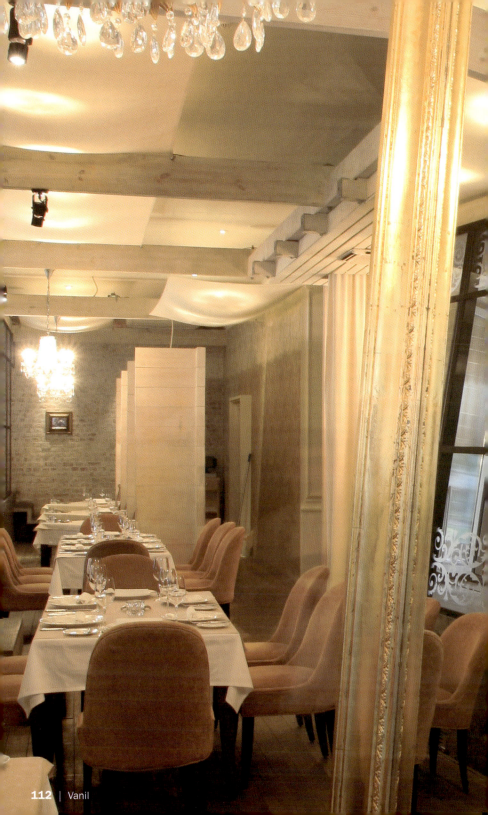

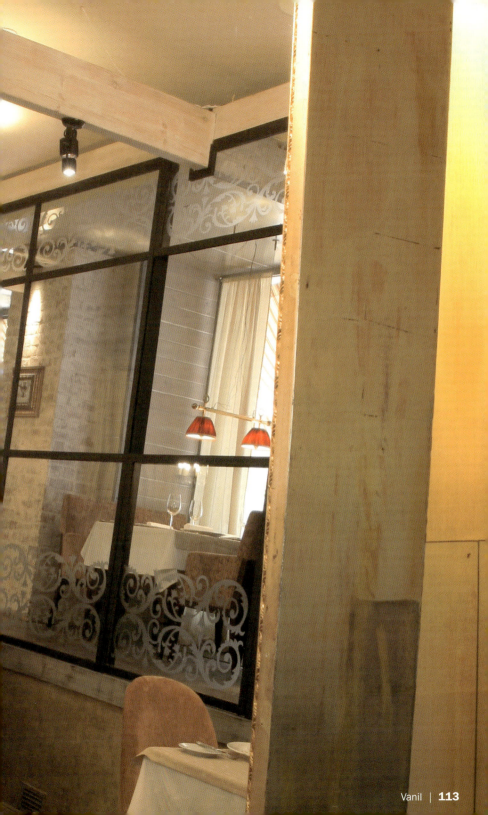

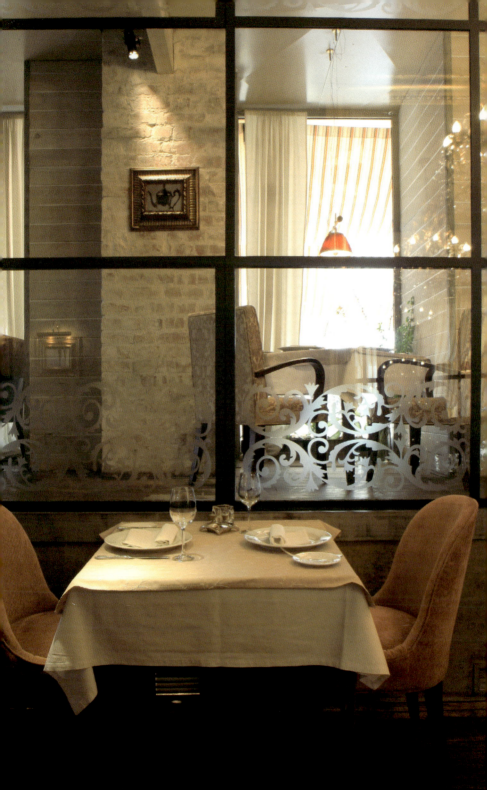

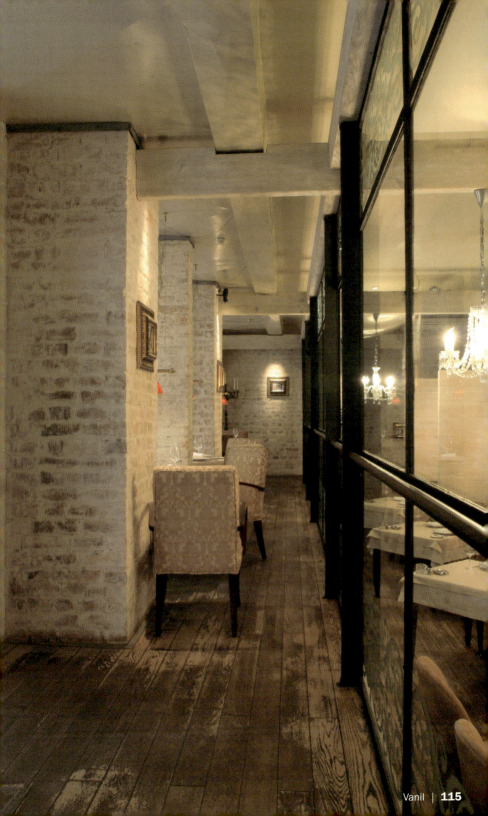

Mixed Salad

Gemischter Salat
Salade mélangée
Ensalada mixta
Insalata mista

7 oz lettuce, washed
2 large carrots
8 green asparagus
2 beams celery
8 cherry tomatoes
12 white button mushrooms
2 tbsp balsamic vinegar
1 tsp garlic, chopped
2 tbsp mixed herbs
2 tbsp olive oil
1 tsp truffle oil
Salt, pepper
8 slices brown bread, toasted
Parsley twigs for decoration

Peel the carrots, cut in thin, long stripes and blanch shortly. Peel the green asparagus and blanch, peel the celery as well, cut into 2 inch pieces and blanch. Cut the cherry tomatoes in half and quarter the mushrooms. Shape the carrot stripes into 12 small circles, fill with the mushrooms and season. Divide the vegetables and lettuce amongst four plates.
Combine balsamic vinegar with garlic, herbs and oils and season with salt and pepper.
Pour the dressing over the salad and serve with parsley twigs and bread slices.

200 g grüner Salat, gewaschen
2 große Karotten
8 Stangen grüner Spargel
2 Stangen Sellerie
8 Kirschtomaten
12 weiße Champignons
2 EL Balsamico-Essig
1 TL Knoblauch, gehackt
2 EL gemischte Kräuter
2 EL Olivenöl
1 TL Trüffelöl
Salz, Pfeffer
8 Scheiben Schwarzbrot, getoastet
Petersilienzweige zur Dekoration

Die Karotten schälen, in dünne, lange Streifen schneiden und kurz blanchieren. Den grünen Spargel schälen und blanchieren, den Staudensellerie ebenfalls schälen, in ca. 5 cm lange Stücke schneiden und blanchieren. Die Kirschtomaten halbieren und die Champignons vierteln. Aus den Karottenstreifen 12 Röllchen formen, mit den Champignons füllen und würzen. Das Gemüse und den Salat auf vier Tellern verteilen.
Balsamico-Essig mit Knoblauch, Kräutern und Ölen mischen und mit Salz, Pfeffer abschmecken.
Das Dressing über den Salat geben und mit Petersilienzweigen und Brotscheiben servieren.

200 g de salade verte lavée
2 grosses carottes
8 tiges d'asperge verte
2 branches de céleri
8 tomates cocktail
12 champignons blancs
2 c. à soupe de vinaigre balsamique
1 c. à café d'ail haché
2 c. à soupe d'herbes variées
2 c. à soupe d'huile d'olive
1 c. à café d'huile de truffe
Sel, poivre
8 tranches de pain noir toasté
Brins de persil pour la décoration

Éplucher les carottes, les couper en longues et fines lamelles et les blanchir rapidement.
Éplucher l'asperge verte et la blanchir, éplucher de même le céleri branche, le couper en morceaux d'env. 5 cm de long et blanchir. Couper les tomates cocktail en deux et les champignons en quatre. Former douze rouleaux avec les lamelles de carottes, les farcir avec les champignons et assaisonner. Répartir les légumes et la salade sur quatre assiettes.
Mélanger le vinaigre balsamique avec l'ail, les herbes et les huiles, puis saler et poivrer.
Napper la salade de sauce et servir avec les tranches de pain et les brins de persil en décoration.

200 g de lechuga lavada
2 zanahorias grandes
8 espárragos verdes
2 tallos de apio
8 tomates cereza
12 champiñones blancos
2 cucharadas de vinagre balsámico
1 cucharadita de ajo picado
2 cucharadas de hierbas frescas varias
2 cucharadas de aceite de oliva
1 cucharadita de aceite de trufa
Sal y pimienta
8 rebanadas de pan negro tostado
Ramitas de perejil para decorar

Pelar las zanahorias en tiras finas y largas y blanquearlas. Pelar los espárragos verdes y escaldarlos, y hacer lo mismo con el apio, una vez pelado y cortado en trozos de unos 5 cm aprox. Cortar a la mitad los tomates cereza y cuartear los champiñones. Formar 12 rollitos con las tiras de zanahoria, rellenarlos con los champiñones y salpimentarlos. Distribuir la verdura y la lechuga en cuatro platos.
Mezclar el vinagre balsámico con ajo, las hierbas y los aceites y salpimentar.
Rociar la ensalada con el aliño y servirla con las ramitas de perejil y el pan negro.

200 g di insalata verde lavata
2 grosse carote
8 asparagi verdi
2 sedani
8 pomodori pachini
12 champignon bianchi
2 cucchiai di aceto balsamico
1 cucchiaino di aglio tritato
2 cucchiai di erbe miste
2 cucchiai di olio di oliva
1 cucchiaino di olio al tartufo
Sale, pepe
8 fette di pane nero tostato
Per la guarnizione: ciuffi di prezzemolo a foglia liscia

Sbucciare le carote, tagliarle a strisce lunghe e sottili e scottarle brevemente. Sbucciare e scottare gli asparagi, sbucciare i sedani, tagliarli a pezzi di circa 5 cm e scottarli. Tagliare a metà i pomodori pachini e gli champignon in quarti. Formare con le strisce di carota 12 rotoli, farcirli con gli champignon e condirli. Disporre le verdure e l'insalata in quattro piatti.
Mescolare l'aceto balsamico con l'aglio, le erbe e gli oli, salare e pepare.
Versare il dressing sull'insalata e servire con i ciuffi di prezzemolo e le fette di pane.

Vertinsky

Design: Stepan Mikhalkov | Chef: Cheong Choi Wan
Owners: Fedor Bondarchuk, Stepan Mikhalkov, Dmitry Zhuk

3, Ostozhenka Street | Moscow 119034 | Khamovniki
Phone: +7 495 202 0570
www.eatout.ru, www.vertinsky.com
Metro: Kropotkinskaya
Opening hours: Every day noon to midnight
Average price: $80
Cuisine: Asian fusion, Russian
Special features: Embraces small boutique with French candies, cakes and chocolate

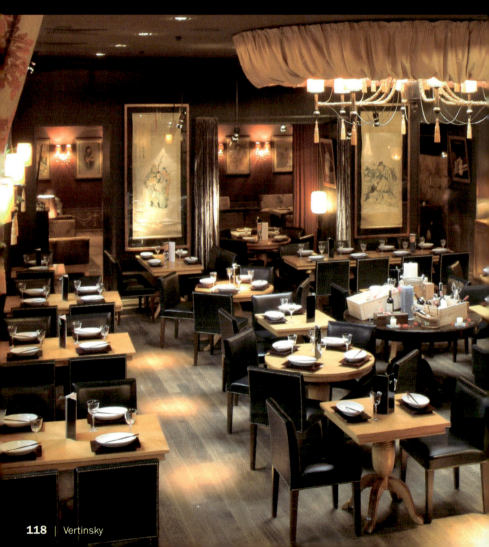

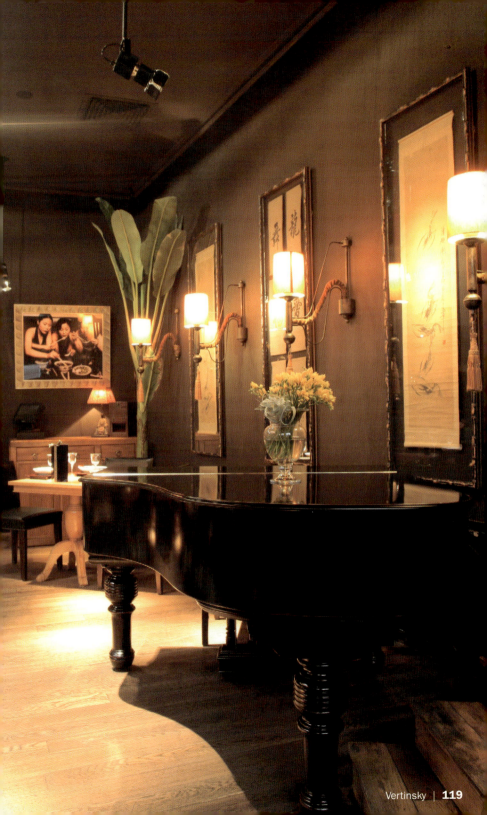

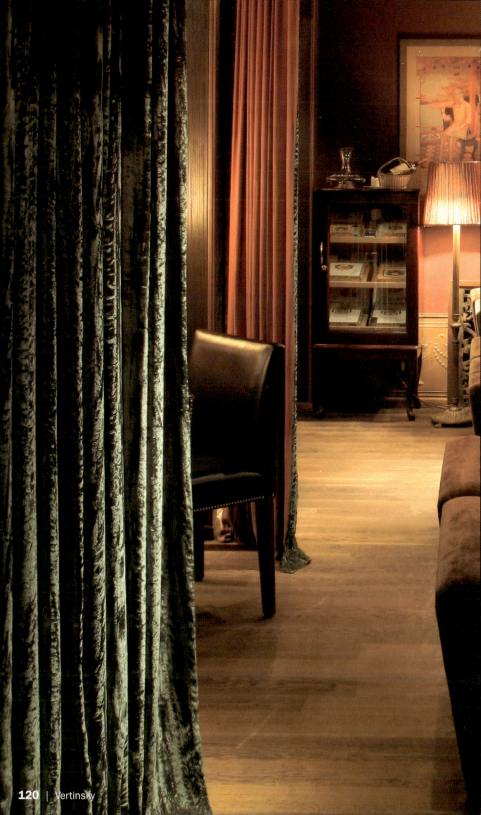

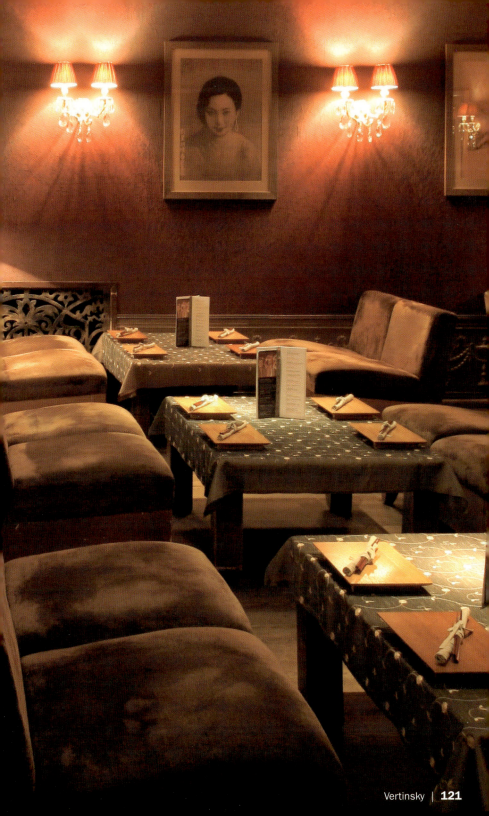

Prawn Rolls with Sesame

Garnelenrollen mit Sesam
Rouleaux de crevettes au sésame
Rollos de gambas con sésamo
Involtini di gamberi al sesamo

1 lb 1 ½ oz prawns without shell
1 tsp corn starch
1 tsp vegetable stock powder
Salt, pepper
12 sheets of nori
Sesame for coating
Vegetable oil for deep-frying
Vegetable julienne for decoration
Sweet chili sauce for dipping

Mince the prawn meat; mix up with corn starch, vegetable stock powder, salt and pepper. Cut the nori sheets in half and stuff with some minced prawn meat. Shape into rolls, coat the endings with sesame and deep-fry at 320 °F for approx. 5 minutes.
Fill the sweet chili sauce in small bowls, place six prawn rolls on each plate, decorate with vegetable julienne and serve immediately.

500 g Garnelen ohne Schale
1 TL Stärke
1 TL Gemüsebrühepulver
Salz, Pfeffer
12 Blatt Nori
Sesam zum Panieren
Pflanzenöl zum Frittieren
Gemüsejulienne zur Dekoration
Sweet-Chili-Sauce zum Dippen

Das Garnelenfleisch fein hacken, mit Stärke, Gemüsebrühenpulver, Salz und Pfeffer würzen. Die Noriblätter halbieren und mit etwas Garnelenhackfleisch füllen. Zu einer Rolle formen. Die Enden mit Sesam panieren und bei 160 °C ca. 5 Minuten frittieren.
Die Sweet-Chili-Sauce in Schälchen füllen, je sechs Garnelenrollen auf die Teller verteilen, mit Gemüsejulienne dekorieren und sofort servieren.

500 g de crevettes décortiquées
1 c. à café de fécule
1 c. à café de bouillon de légumes en poudre
Sel, poivre
12 feuilles de nori
Sésame pour paner
Huile végétale pour la friture
Julienne de légumes pour la décoration
Sauce sweet chili pour tremper

Hacher finement la chair des crevettes, assaisonner avec la fécule, le bouillon de légumes en poudre, le sel et le poivre. Couper les feuilles de nori en deux et les farcir avec un peu de chair de crevettes. Former des rouleaux, paner les extrémités avec du sésame et frire à 160 °C env. 5 minutes.
Remplir de petites jattes de sauce sweet chili, déposer six rouleaux de crevettes sur les assiettes et décorer de julienne de légumes. Servir de suite.

500 g de gambas peladas
1 cucharadita de almidón
1 cucharadita de caldo de verdura en polvo
Sal y pimienta
12 láminas de nori
Sésamo para empanar
Aceite vegetal para freír
Juliana de verdura para decorar
Salsa de chiles dulces para untar

Picar las gambas, mezclarlas con la almidón, el caldo de verdura en polvo y salpimentarlas. Cortar por la mitad las láminas de nori y rellenarlas con un poco de la mezcla de gambas y enrollarlas. Empanar los extremos de los rollos con sésamo y freírlos a 160 °C durante 5 minutos aprox.
Verter la salsa de chiles dulces en cuencos pequeños, colocar seis rollos de gamba en cada plato, decorarlos con la juliana de verduras y servirlos al instante.

500 g di gamberi sgusciati
1 cucchiaio di amido
1 cucchiaino di brodo granulato vegetale
Sale, pepe
12 fogli di nori
Per la panatura: sesamo
Olio vegetale per friggere
Per la guarnizione: verdure tagliate a julienne
Salsa chili dolce come intingolo

Tritare finemente la polpa di gambero e condirla con l'amido, il brodo granulato, sale e pepe. Tagliare a metà i fogli di nori e farcirli con un po' di polpa di gambero. Arrotolarli e passare le estremità degli involtini nel sesamo e friggerli per 5 minuti a circa 160 °C.
Versare la salsa chili in alcune ciotoline, disporre sei involtini di gambero in ciascun piatto e guarnire con le julienne di verdure. Servire subito.

Villa

Design: Yuriy Andreev | **Chef:** Carlo Grecu | **Owner:** Mikhail Gokhner

48, Myasnitskaya Street | Moscow 107078 | Meshchanskoe
Phone: +7 495 925 4715, +7 495 925 9240
www.villa.su
Metro: Krasnye Vorota
Opening hours: Every day noon to midnight
Average price: $90
Cuisine: Italian

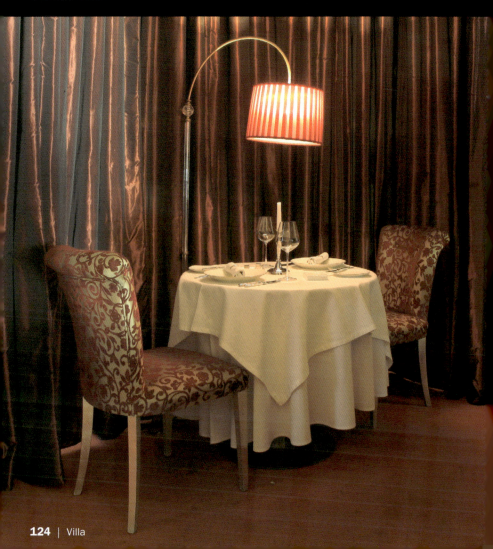

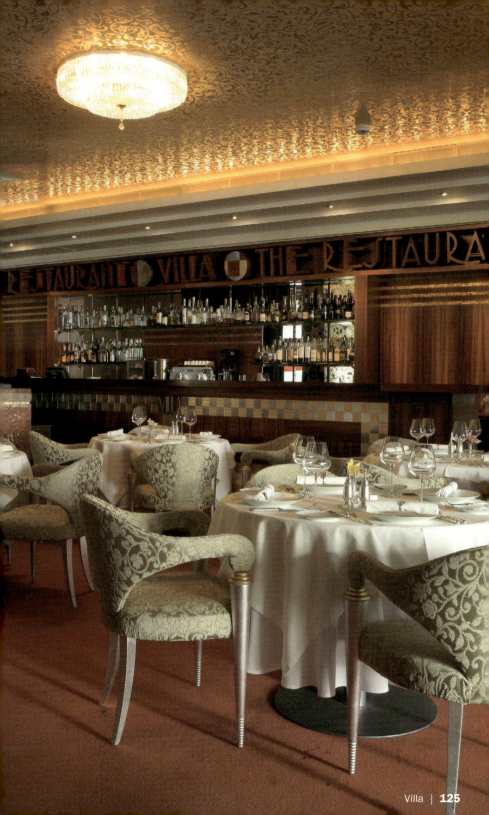

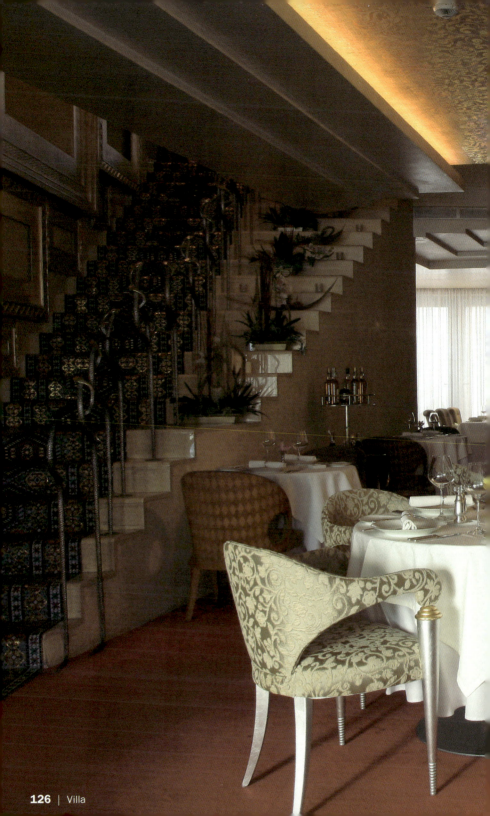

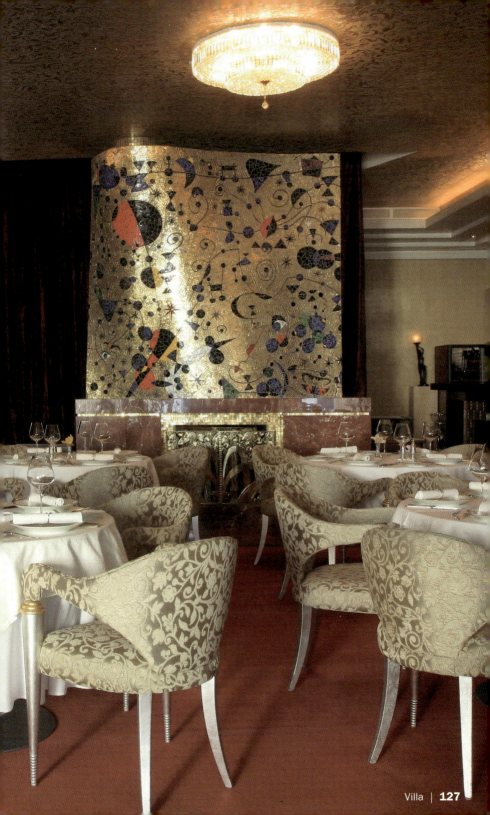

Vogue Café

Design: Ann Boyd | Chef: Yury Rozhkov | Owner: Arkady Novikov

7/9, Kuznetsky Street | Moscow 103031 | Tverskoe
Phone: +7 495 623 1701
www.novikovgroup.ru
Metro: Kuznetsky Most, Lubyanka
Opening hours: Mon–Thu 8:30 am to 1 am, Fri 8:30 am to 2 am, Sat noon to 2 am, Sun noon to 1 am
Average price: $50
Cuisine: Eclectic, International
Special features: The place to see and be seen

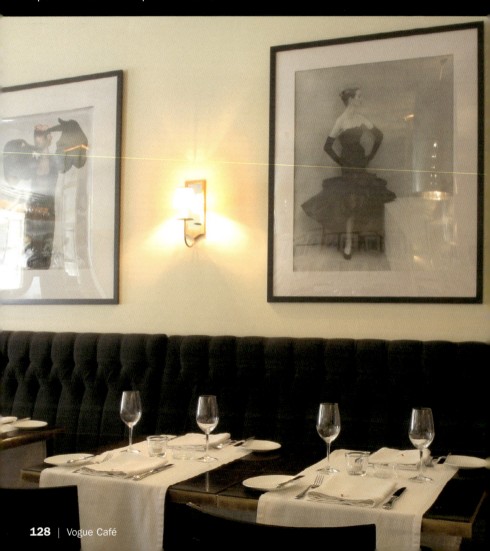

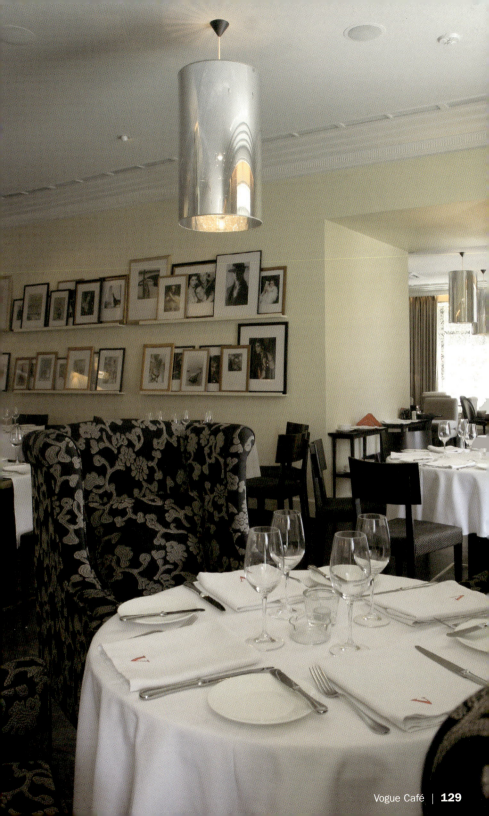

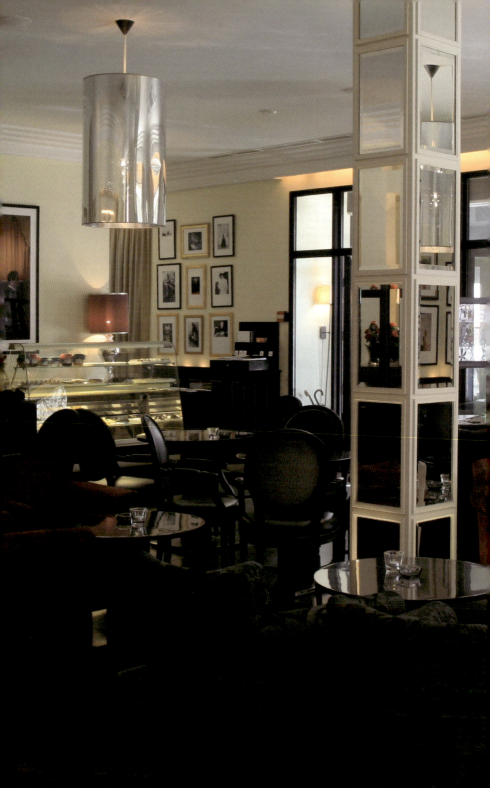

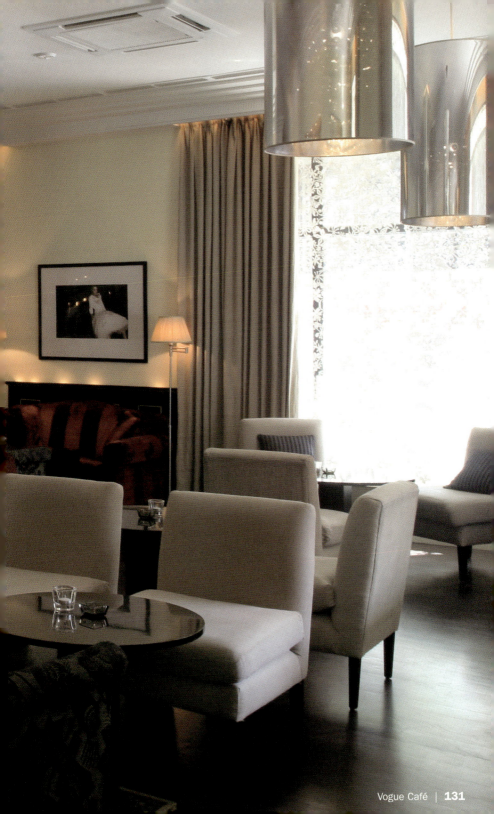

Duck Leg Confit
with Buckwheat and Porcini

Entenkeulenconfit mit Buchweizen und Steinpilzen

Confit de cuisse de canard avec sarrasin et cèpes

Confit de muslo de pato con alforfón y boletos

Confit di cosce d'anatra con grano saraceno e funghi porcini

4 duck legs
3 tbsp vegetable oil
500 ml chicken stock
300 ml gravy
3 ½ oz ginger
Salt, pepper
Sear the duck legs, remove from the pan and place in a baking dish, deglaze the drippings with stock and gravy, add the herbs and season. Pour the fond over the legs and braise covered at 400 °F for approx. 2 hours.

3 ½ oz dried porcini
2 tbsp butter
2 tbsp olive oil
1 clove of garlic, chopped
1 twig thyme
Salt, pepper
Place the mushrooms in a bowl and cover with warm water. Let soak for approx. 3 hours, then drain the mushroom fond and reserve. Cut the mushrooms in half, if needed and sear in butter oil mix. Add garlic and thyme and season with salt and pepper.

14 oz buckwheat
300 ml porcini fond
4 oz butter
Salt, pepper
Cook the buckwheat in mushroom fond until tender, sear in butter and season.

Divide the buckwheat among four plates, spread the mushrooms on top and place one duck leg in the middle. Garnish with chopped herbs.

4 Entenkeulen
3 EL Pflanzenöl
500 ml Geflügelbrühe
300 ml Bratensaft
100 g Ingwer
Salz, Pfeffer
Die Entenkeulen scharf anbraten, aus der Pfanne nehmen und in eine Auflaufform geben, den Bratensatz mit Brühe und Bratensaft ablöschen, die Gewürze zugeben und abschmecken. Den Fond über die Keulen geben und zugedeckt bei 200 °C ca. 2 Stunden schmoren.

100 g getrocknete Steinpilze
2 EL Butter
2 EL Olivenöl
1 Knoblauchzehe, gehackt
1 Zweig Thymian
Salz, Pfeffer
Die Steinpilze in eine Schüssel geben und mit warmem Wasser bedecken. Ca. 3 Stunden einweichen lassen, dann den Pilzsud abgießen und aufbewahren. Die Steinpilze evtl. halbieren und in der Butter-Öl-Mischung anbraten. Knoblauch und Thymian zugeben und mit Salz und Pfeffer abschmecken.

400 g Buchweizen
300 ml Steinpilzsud
120 g Butter
Salz, Pfeffer
Den Buchweizen in dem Pilzsud gar kochen, in Butter anbraten und würzen.

Den Buchweizen auf vier Tellern verteilen, die Pilze darauf geben und jeweils eine Entenkeule in die Mitte setzen. Mit gehackten Kräutern garnieren.

4 cuisses de canard
3 c. à soupe d'huile végétale
500 ml de bouillon de volaille
300 ml de jus de rôti
100 g de gingembre
Sel, poivre
Saisir les cuisses de canard à feu vif, les retirer de la poêle et les mettre dans un moule à gratin. Mouiller le fond de cuisson avec le bouillon et le jus de rôti, ajouter les épices et rectifier l'assaisonnement. Verser le fond sur les cuisses et cuire à couvert à 200 °C env. 2 heures.

100 g de cèpes séchés
2 c. à soupe de beurre
2 c. à soupe d'huile d'olive
1 gousse d'ail haché
1 branche de thym
Sel, poivre

Mettre les cèpes dans une jatte et recouvrir d'eau chaude. Laisser tremper env. 3 heures, égoutter et conserver l'eau de trempage. Couper éventuellement les cèpes en deux et les faire sauter dans le mélange beurre huile. Ajouter l'ail et le thym, saler et poivrer.

400 g de sarrasin
300 ml d'eau de trempage des cèpes
120 g de beurre
Sel, poivre
Faire cuire complètement le sarrasin dans l'eau des cèpes, le faire revenir dans le beurre et l'assaisonner.

Répartir le sarrasin sur quatre assiettes, disposer les cèpes dessus et placer une cuisse de canard au milieu. Garnir avec les herbes hachées.

4 muslos de pato
3 cucharadas de aceite vegetal
500 ml de caldo de ave
300 ml de jugo de asado
100 g de jengibre
Sal y pimienta
Dorar los muslos de pato, sacarlos de la sartén y colocarlos en una fuente. Reducir el jugo de la sartén con caldo y jugo de asado, añadirle las especias y sazonar. Rociar la reducción sobre los muslos, taparlos y cocinarlos en el horno a 200 °C durante 2 horas aprox.

100 g de boletos secos
2 cucharadas de mantequilla
2 cucharadas de aceite de oliva
1 diente de ajo picado
1 ramita de tomillo
Sal y pimienta

Cubrir las setas con agua caliente en un bol y dejar que se ablanden durante 3 horas. A continuación sacarlas y reservar el agua. Cortar los boletos a la mitad si es necesario y rehogarlos en una mezcla de aceite y mantequilla. Añadir el ajo y el tomillo y salpimentarlos.

400 g de alforfón mondado
300 ml del agua de los boletos
120 g de mantequilla
Sal y pimienta
Cocer el alforfón en el agua de los boletos, rehogarla en mantequilla y salpimentarla.

Distribuir el alforfón en cuatro platos, añadir los boletos y colocar en el centro un muslo de pato respectivamente. Decorar con hierbas frescas picadas.

4 cosce d'anatra
3 cucchiai di olio vegetale
500 ml di brodo di pollo
300 ml di sugo d'arrosto
100 g di zenzero
Sale, pepe
Rosolare a fuoco vivo le cosce d'anatra, estrarle dalla padella e disporle in uno stampo. Bagnare il fondo con il brodo e il sugo d'arrosto, unire gli aromi e regolare il condimento. Versare il fondo sulle cosce e lasciarle cuocere coperte per circa 2 ore a 200 °C.

100 g di funghi porcini secchi
2 cucchiai di burro
2 cucchiai di olio di oliva
1 spicchio d'aglio tritato
1 rametto di timo
Sale, pepe

Mettere i funghi in una ciotola e coprirli con acqua calda. Lasciarli a mollo per circa 3 ore, quindi scolarli e conservare l'acqua di ammollo. Eventualmente, tagliare i funghi a metà e rosolarli in olio e burro. Aggiungere l'aglio e il timo, salare e pepare.

400 g di grano saraceno
300 ml di acqua di ammollo dei funghi porcini
120 g di burro
Sale, pepe
Cuocere il grano saraceno nell'acqua di ammollo dei funghi, rosolarlo nel burro e condirlo.

Ripartire il grano saraceno in quattro piatti, disporvi sopra i funghi e collocare una coscia d'anatra al centro di ciascun piatto. Guarnire con le erbe tritate.

No.	Restaurant	Page
1	Biscuit	10
2	Bocconcino	16
3	Bosco Bar	18
4	Cantinetta Antinori	22
5	City Space Bar & Lounge	28
6	Dolf	32
7	Galereya	38
8	Garage	44
9	Genatsvale VIP	48
10	Gorki	50
11	Indus	52
12	Le Duc	58
13	Maki Café	60
14	Metropol	62
15	Mon Café	64
16	Moskovsky	68
17	Nostalgie	70
18	Oblomov	74
19	Pavillion	78
20	Peperoni	84
21	Propaganda	88
22	Shatush	92
23	Shinok	98
24	Suzy Wong	100
25	Uley	106
26	Vanil	110
27	Vertinsky	118
28	Villa	124
29	Vogue Café	128

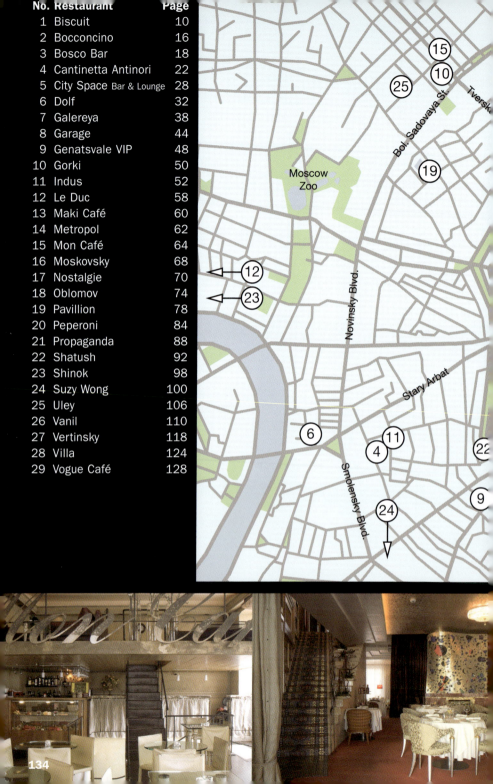

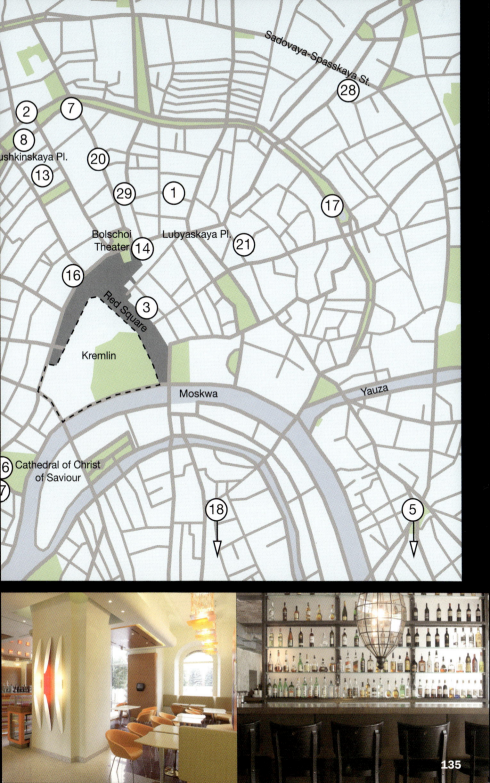

Cool Restaurants

Amsterdam
ISBN 3-8238-4588-8

Barcelona
ISBN 3-8238-4586-1

Berlin
ISBN 3-8238-4585-3

Brussels (*)
ISBN 3-8327-9065-9

Cape Town
ISBN 3-8327-9103-5

Chicago
ISBN 3-8327-9018-7

Cologne
ISBN 3-8327-9117-5

Copenhagen
ISBN 3-8327-9146-9

Côte d'Azur
ISBN 3-8327-9040-3

Dubai
ISBN 3-8327-9149-3

Frankfurt
ISBN 3-8327-9118-3

Hamburg
ISBN 3-8238-4599-3

Hong Kong
ISBN 3-8327-9111-6

Istanbul
ISBN 3-8327-9115-9

Las Vegas
ISBN 3-8327-9116-7

London 2nd edition
ISBN 3-8327-9131-0

Los Angeles
ISBN 3-8238-4589-6

Madrid
ISBN 3-8327-9029-2

Mallorca/Ibiza
ISBN 3-8327-9113-2

Miami
ISBN 3-8327-9066-7

Milan
ISBN 3-8238-4587-X

Moscow
ISBN 3-8327-9147-7

Munich
ISBN 3-8327-9019-5

New York 2nd edition
ISBN 3-8327-9130-2

Paris 2nd edition
ISBN 3-8327-9129-9

Prague
ISBN 3-8327-9068-3

Rome
ISBN 3-8327-9028-4

San Francisco
ISBN 3-8327-9067-5

Shanghai
ISBN 3-8327-9050-0

Sydney
ISBN 3-8327-9027-6

Tokyo
ISBN 3-8238-4590-X

Toscana
ISBN 3-8327-9102-7

Vienna
ISBN 3-8327-9020-9

Zurich
ISBN 3-8327-9069-1

COOL SHOPS

BARCELONA
ISBN 3-8327-9073-X

BERLIN
ISBN 3-8327-9070-5

HAMBURG
ISBN 3-8327-9120-5

HONG KONG
ISBN 3-8327-9121-3

LONDON
ISBN 3-8327-9038-1

LOS ANGELES
ISBN 3-8327-9071-3

MILAN
ISBN 3-8327-9022-5

MUNICH
ISBN 3-8327-9072-1

NEW YORK
ISBN 3-8327-9021-7

PARIS
ISBN 3-8327-9037-3

TOKYO
ISBN 3-8238-9122-1

COOL SPOTS

LAS VEGAS
ISBN 3-8327-9152-3

MALLORCA/IBIZA
ISBN 3-8327-9123-X

MIAMI/SOUTH BEACH
ISBN 3-8327-9153-1

Size: 14 x 21.5 cm
5 1/2 x 8 1/2 in.
136 pp, Flexicover
c. 130 color photographs
Text in English, German, French
Spanish, Italian or (*) Dutch

teNeues